Amesbury

June 2008

Dear Neil—

Thank you so much for taking such good care of the Healey girls and driving them safely all these years.

We will miss your smiling face and happy disposition.

Hope to see you around Amesbury.

Good luck and great health to you.

Fondly,
Rachel, Kate and Julia
Healey

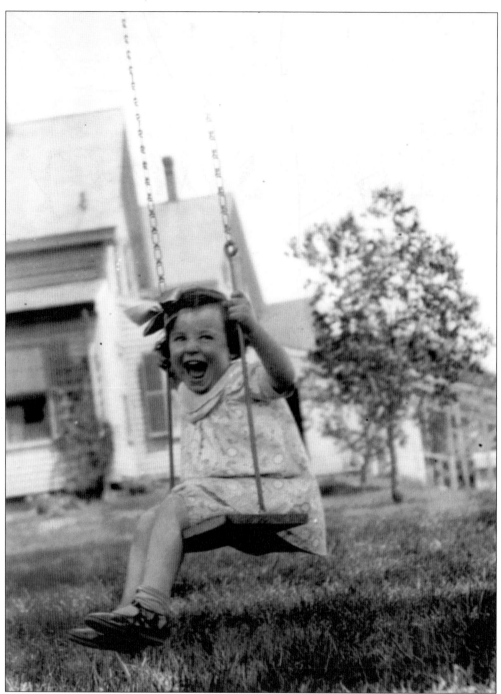

Amesbury is a friendly community where children can be raised with a strong sense of self and heritage without even being aware of that kinship being cultivated. Shown here in 1933, three-year-old Mary Jane Hession enthusiastically takes pleasure in the simple swing her father, John, draped over a branch from the majestic elm tree in the yard. In the background is 355 Main Street at Point Shore, the family home that they shared with wife and mother Anne for several decades.

POSTCARD HISTORY SERIES

Amesbury

Charles J. Pouliot

ARCADIA

Published by Arcadia Publishing,
an imprint of Tempus Publishing, Inc.
2A Cumberland Street
Charleston, SC 29401

Printed in Great Britain.

Library of Congress Catalog Card Number: 2002110401

For all general information contact Arcadia Publishing at:
Telephone 843-853-2070
Fax 843-853-0044
E-Mail sales@arcadiapublishing.com

For customer service and orders:
Toll-Free 1-888-313-2665

Visit us on the internet at http://www.arcadiapublishing.com

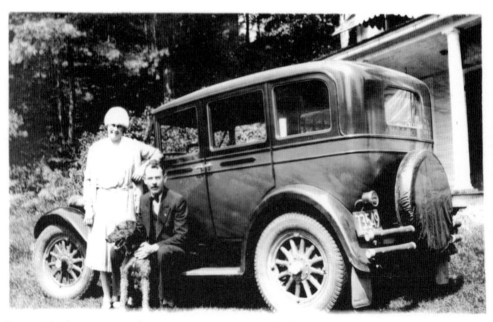

Anne and John Hession of 355 Main Street pose with their terrier Zock on the running board of their family automobile in the late 1920s. The Hessions were residents of Point Shore for more than 60 years. John was an electrician in Amesbury, and Anne was a teacher and local pastel artist. The same Massachusetts license plate number, 73549, was in the family until it was turned in to the registry in 2001.

CONTENTS

ACKNOWLEDGMENTS

I wish to dedicate this book to three women whose wisdom and encouragement are carried with me each and every day, and who have helped me immeasurably in completing this project.

First, my maternal grandmother, Anne Gladys Hession, was a person whose knowledge was so vast that in several lifetimes, I could never scratch the surface of what she could unhesitatingly talk about. Through her, I was learning about Amesbury's rich heritage before I could walk.

Second, my loving mother, Mary Jane Pouliot, could make your simplest successes feel like you just discovered the cure for cancer. No one else on this earth could leave behind so much sadness at his or her departure. Everyone who ever knew her misses her.

Third, my wife and sweetheart, Teri, puts up with my countless projects and has provided me with a love and life I never thought possible. Throughout the trips to Amesbury to discover "what was" and visiting virtually every store that might sell an old memory, she showed a patience and support that I can never repay.

I would like to thank the Amesbury Public Library staff for making the library a marvelous hunting ground for Amesbury's heritage, and especially reference librarian Jen Haven for wholeheartedly making me feel like a "member of the family."

I must also thank all who have played a role in documenting Amesbury's history in one form or another—especially the estimable Joseph Merrill, Sara Locke Redford, and Willard E. Flanders, who made the research and documentation of Amesbury such a passion work in their lives.

Many thanks also go to my Arcadia editor, Jill Anderson, whose enthusiasm and unreserved happiness made the creation of this book easy and gave me the motivation to take it up a notch.

INTRODUCTION

Amesbury was settled by Europeans in 1642 and incorporated in 1668. Along with its rugged 19th-century commercial buildings, Amesbury has many beautiful Federal-period residences and local historical sites, which the community carefully preserves as its link with the past.

The territory comprising the present town of Amesbury was originally a part of Salisbury. On May 23, 1666, "Salisbury-new-town" was granted the privileges of a town, and on May 27, 1668, the name was changed to Amesbury. In the Massachusetts Bay Colony records, the name is entered as Emesbury.

The town's earliest industries included various mills, shipyards, and a greatly used ferry business crossing the Merrimac River to Newburyport. By the 19th century, Amesbury's shipbuilding and fishing industries were repositioning to textiles, ironworks, wood mills, and gristmills, which processed grains. These had all been established along the 90-foot drop of the Powow River, which provided formidable waterpower.

Two of Amesbury's most famous industries were hat making and carriage building. Amesbury's carriage industry enjoyed a substantial reputation in the area and briefly transitioned into making automobile bodies until the Great Depression.

This book will display and describe in detail the subject of each postcard from my personal collection of postcards of the town of Amesbury. Some photographs purchased along the hunt will be shown here, too. The focus of this book is a trip to town, beginning at the Newburyport-Amesbury border where the Chain Bridge brings you to Deer Island, proceeding along Main Street through the historic Point Shore area, visiting notable historic landmarks along the way, and concluding the trip in downtown Amesbury. As each landmark is encountered, an anecdote or description of its local and historic significance will be related. If an interrelation to other people and landmarks of the area exists, that anecdote will also be told. If warranted, definitions and descriptions of unusual terms or signs of the times will be included.

The time period reflected in the images dates as far back as the end of the 19th century and as recent as the 1960s, with the foundation of the collection reflecting the first two decades of the 1900s. The source of the images is my own collection of postcards, which have been gathered by browsing through countless antiques stores and flea markets throughout New England, and by participating in many Internet auctions.

This collection of postcards provides an interesting perspective to the way Amesbury was, and how much effort has been placed into retaining the historic heritage of the town. Many of the subjects of the close to century-old cards are currently in better condition than when the

photographs were taken, due to renovation and preservation efforts and modern construction techniques. Amesbury's town management should be well commended for their efforts.

Some of Amesbury's landmarks—most notably the ones to be found at or near the current location of the Amesbury Middle School—have been significantly altered through decades of community progress and honorable restoration efforts. For instance, there are several postcards— each displaying an extensively different scene—of the Captain's Well. When the progression of change can be unraveled through historic town documents, it will be recounted in this book.

Amesbury has strong ties to poet John Greenleaf Whittier, a longtime resident whose modest home continues to stand at the corner of Friend and Pickard Streets, and there are several locations that had either provided inspiration for his poems, or his poems provided inspiration for them. Whenever such a link exists, the location will be described and passages of Whittier's poems will be presented. Whittier had an extraordinary ability to present an all-embracing mood with just several words of prose, and it is offered that the included stanzas of his poetry uniquely complement the postcards.

As best as can be established through available sources, and whenever historic accounts conflict, well-known facts will be provided for the reader to develop their own conclusion. In specific cases, the telling of a story may lead to another tale. If this opportunity presents itself, the additional tale will be provided. Such would be the case during the description of the Thomas Macy home and Macy's self-imposed banishment from Amesbury. The cause of the banishment—harboring Quakers—further reveals that two of the four Quakers were hung in Boston.

This book of Amesbury, realized through vintage postcards, provides a guided and informative tour through an interesting and historically unique town—one with a proud early-American heritage and a living story to tell.

One

BRIDGING THE
MERRIMAC

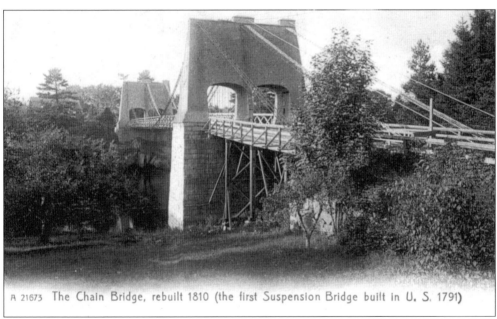

A 21673 The Chain Bridge, rebuilt 1810 (the first Suspension Bridge built in U. S. 1791)

The Chain Bridge is a 225-foot, single-span suspension bridge, which crosses the river at the site of two past bridges—a previous Palladian arched timber truss bridge (1792–1810), built by Timothy Palmer, and a wrought-iron chain suspension bridge (1810–1909), designed by James Finley and built by John Templeman. At the time of the current bridge's construction in 1909, it incorporated the most up-to-date technology. George F. Swain, the bridge's designer, was a nationally recognized structural engineer and educator. According to the Massachusetts Department of Public Works Historic Bridge Inventory, the Chain Bridge is the state's only highway suspension bridge.

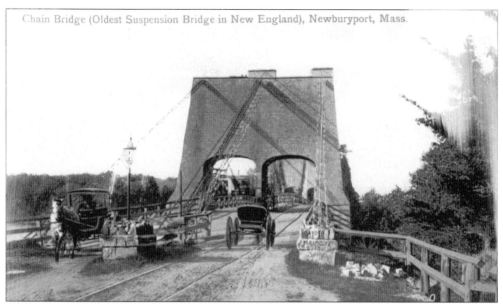

Chain Bridge (Oldest Suspension Bridge in New England), Newburyport, Mass.

The name of the bridge has been a topic of controversy for decades. Some call the bridge the Essex-Merrimac Bridge, and some call it the Chain Bridge. The names are even interchanged in official government documents. The only sure thing is that the bridge from the opposite side of Deer Island to Amesbury has always been known as the Essex-Merrimac Bridge in text. It may be possible that the two bridges were known jointly as the Essex-Merrimac Bridge at one time, but residents adopted the Chain Bridge name for the Newburyport-to-Deer Island span.

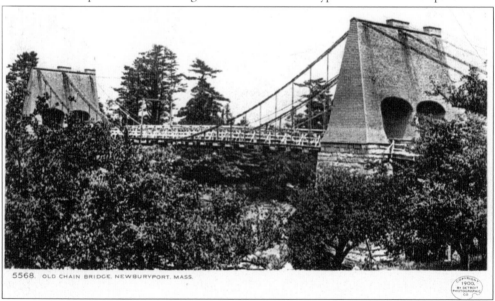

5568. OLD CHAIN BRIDGE, NEWBURYPORT, MASS.

The Chain Bridge shown here is the second generation of the bridge. The first was built of two timber arch spans anchored to heavy timber cribs filled with stone. The design may have evolved from shipbuilding techniques. An average life span for an uncovered wooden bridge such as this one was 20 years, and in 1810, the owners decided to replace the timber arch with a chain-suspension design. John Templeman was chosen to build the new bridge based on the patented suspension design of James Finley of Pennsylvania, who built well over 40 of this type.

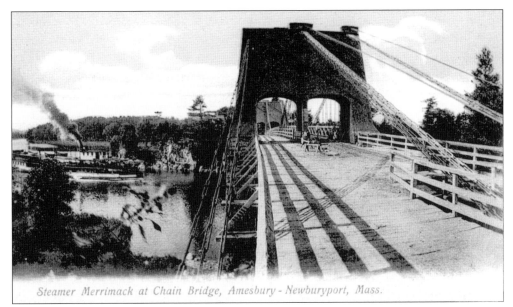

Steamer Merrimack at Chain Bridge, Amesbury - Newburyport, Mass.

The Chain Bridge design called for wrought-iron bar chain links passed over timber towers with suspended wood floors. From tower to tower, the bridge measured 243 feet long. The towers rested on massive granite piers and consisted of heavy timber framing. Ten wrought-iron chains, each 516 feet long, were anchored to the ground, passed over the towers, and connected by suspenders to the floor joists. The chains supported two 14-foot-wide roadways, and iron beams supported the floor beams, except in the center, where the roadway lay directly on the chains.

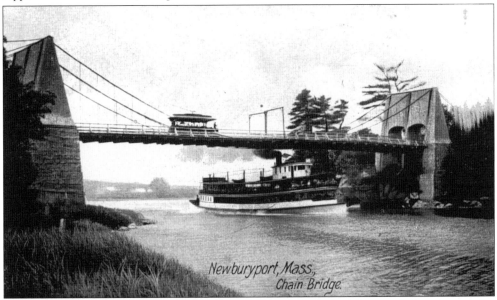

Newburyport, Mass., Chain Bridge.

This postcard was taken from an original pastel drawing chalked by noted Amesbury artist, photographer, historian, and lecturer Willard E. Flanders. It features the James Finley design of the bridge and shows an electric trolley from *c.* 1890 on its way to Amesbury and an excursion steamer heading toward Plum Island. Flanders's contributions to Amesbury's legacy are enormous. Throughout his life, Flanders created countless artworks, photographs, and lectures of events and minutiae from Amesbury's history that otherwise would have been lost.

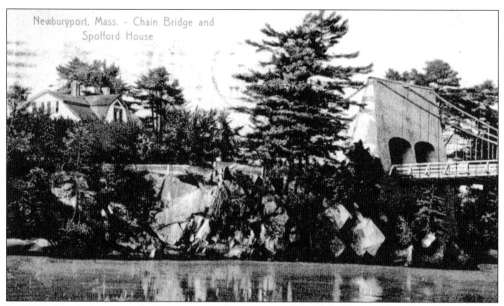

Newburyport, Mass. - Chain Bridge and Spofford House

In 1682, in exchange for a bell donated to the First Church of Salisbury, the administrators of the town of Salisbury presented Deer Island, located in the Merrimac River between Amesbury and Newburyport, to George Hewes. The exceptional gambrel-roofed Colonial house is located on Deer Island and existed even prior to the first bridge being built in 1792. It was known as the Pearson Tavern and opened to travelers on the same date as the bridge. Tolls were collected until 1868, when it became a "free" bridge. The tavern was famous for being a place where George Washington once stopped while touring New England in 1789.

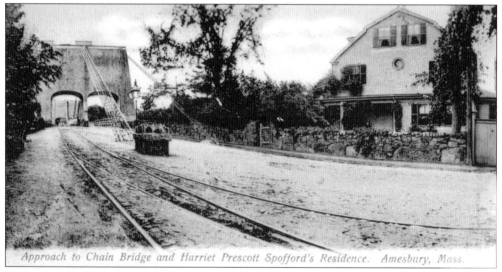

Approach to Chain Bridge and Harriet Prescott Spofford's Residence. Amesbury, Mass.

In the late 1700s and early 1800s, one could attend annual suppers, dances, and blowouts at Pearson Tavern on Deer Island. In 1875, lawyer Richard S. Spofford of Newburyport bought the island and the house. Harriet Elizabeth Prescott Spofford, the wife of the new owner, was a well-known mainstream writer of detective stories, science fiction, and romance tales and was one of America's most famous women writers and poets. She was also a friend and associate of John Greenleaf Whittier, Ralph Waldo Emerson, Henry Wadsworth Longfellow, and other writers of that era. She lived on the island for almost half a century until her death in 1921.

12

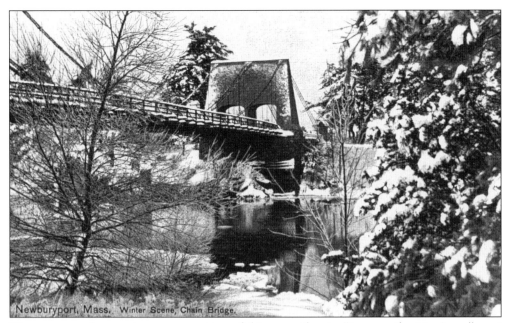

Newburyport, Mass. Winter Scene, Chain Bridge.

There was much marvelous prose written of this area. Also, in "June on the Merrimac," poet John Greenleaf Whittier referred to Deer Island's Harriet Prescott Spofford: "The Hawkswood oaks, the storm-torn plumes / Of old pine-forest kings, / Beneath whose century-woven shade / Deer Island's mistress sings."

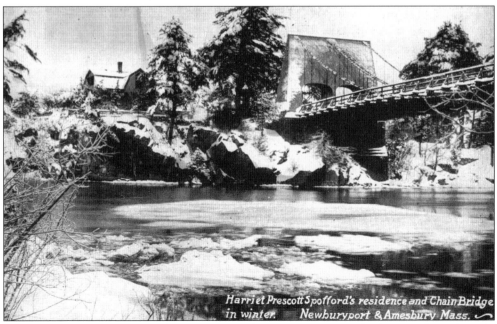

Harriet Prescott Spofford's residence and Chain Bridge in winter. Newburyport & Amesbury Mass.

The Chain Bridge has provided inspiration for poets, artists, and photographers since its construction. These romantic scenes are two extremely popular postcards of the Chain Bridge, both depicting the view toward Amesbury from the Newburyport riverbanks of the Merrimac.

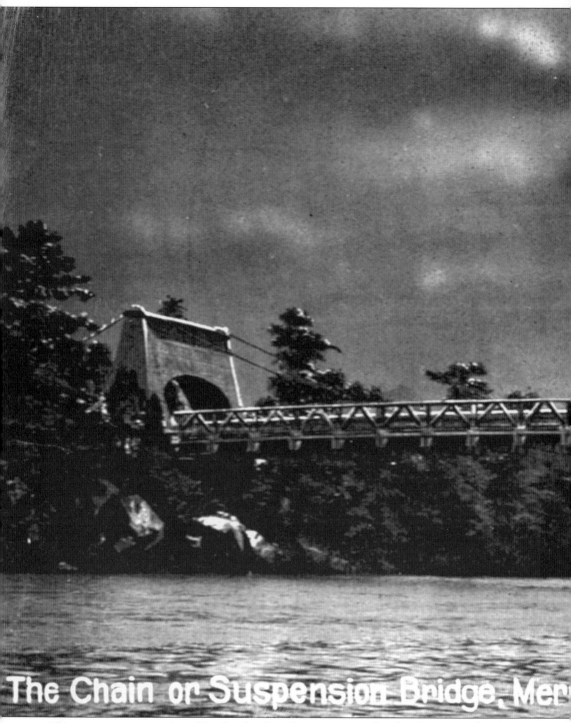

The Chain or Suspension Bridge, Mer

This panorama appears dreamlike, but local residents can attest that they have seen this exquisite image often by visiting Newburyport's Moseley's Pines in the twilight of a full moon and gazing toward the bridge. These beautiful scenes might never have happened at all if not for progress. In 1791, the bridges to Deer Island were opposed due to the idea that the abutments and piers

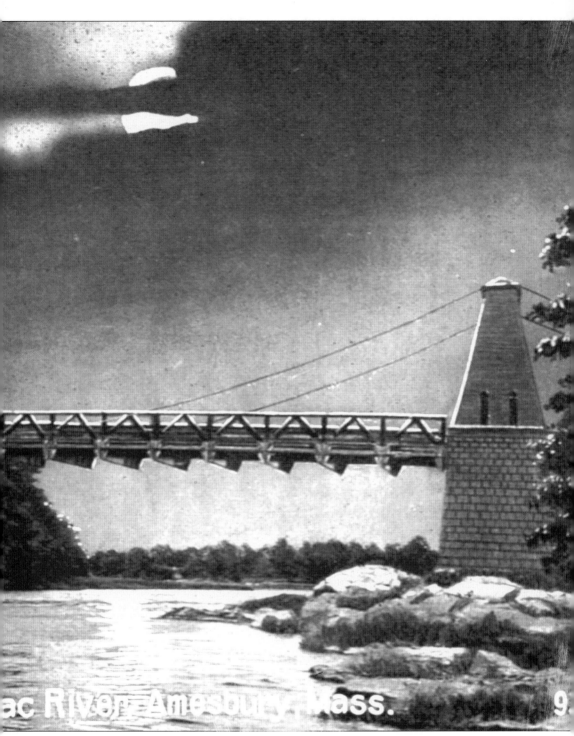

ac River, Amesbury, Mass. 9

of the bridges would be so narrow that the ice and freshets would be held back and the shipyards would be flooded. It was quite a prophetic consideration, because during the flood of 1936, it is exactly what happened.

Merrimac River and Rustic Boat Landing from the Chain Bridge, Amesbury, Mass.

9325

On the Spofford property of Deer Island, there was a summer gazebo built in 1875 almost exclusively of tree branches, on a tiny isle that was attached to Deer Island by a bridged walkway from a private boat dock. During the great flood in March 1936, the gazebo was sheared off by ice floes, completely destroyed, and both the gazebo and isle were washed away and never seen again.

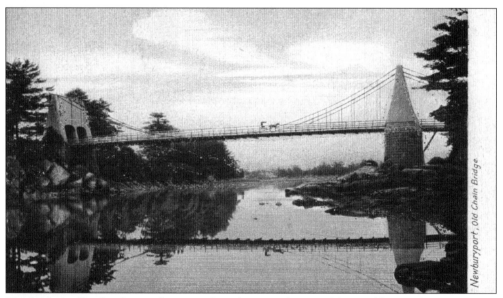

Newburyport, Old Chain Bridge.

The bridge suffered only one disaster. After a heavy and very cold snowfall on February 6, 1827, David Jackman and Frederick Carleton, with a bulky wagon loaded with timber pulled by a team of six oxen and two horses, attempted to cross the bridge. The combination of the weight and the cold caused the chains to shatter, and their load, the oxen, and part of the bridge fell into the swift river current below. The men and horses survived, but the oxen drowned. The bridge was quickly rebuilt with two additional support chains and has provided safe passage since.

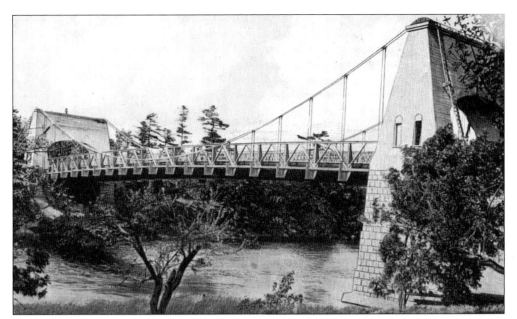

By the late 1800s, the bridge was showing signs of age. Traffic increased, including a streetcar line in 1870 that moved from horsepower to electricity in 1891 and placed the bridge under much stress. Many streetcar passengers refused to ride over the bridge due to the swaying and bucking under heavy loads and opted to walk across and reboard the trolley on the other side. In 1894, the chains were reinforced with steel cables.

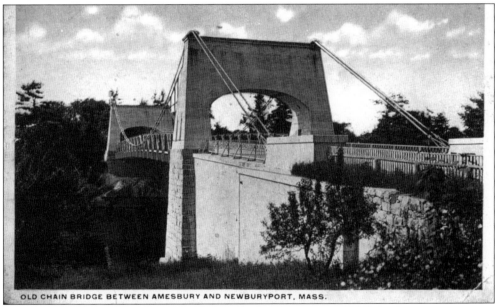

OLD CHAIN BRIDGE BETWEEN AMESBURY AND NEWBURYPORT, MASS.

In 1909, George Fillmore Swain was contracted to rebuild or replace the bridge. After inspecting the site, it was determined that the existing construction was inadequate for the required capacity, but popular demands required that the bridge maintain its current appearance. Swain wrote a plan that called for reinforced concrete towers and enhanced cable anchors. The old bridge was removed in 1909, and all iron parts were tossed to the bottom of the Merrimac River. A walkway was provided for foot traffic and led to a trolley on the other side.

17

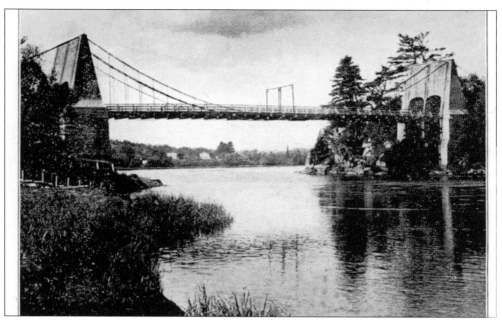

During the winter of 1909–1910, weather conditions temporarily halted construction by the American Bridge Company, but the bridge opened in June 1910. Modifications have been few over the years. The original timber deck was replaced in 1922 and 1931, and the streetcar tracks were removed when the roadbed was replaced with an open steel grid deck in 1938. In the early 1980s, the wire cables were rewrapped, and the bridge's metalwork was painted blue.

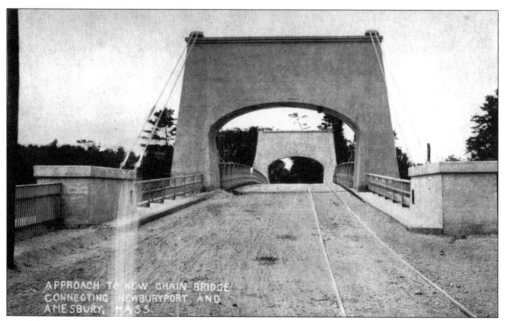

APPROACH TO NEW CHAIN BRIDGE
CONNECTING NEWBURYPORT AND
AMESBURY, MASS.

In 1951, closing the Chain Bridge was considered when the state built the John Greenleaf Whittier Memorial Bridge to cross the river nearby. Concerned citizens rallied together to complain about the loss of the roadway and express feelings for this vestige of the past. The bridge has essentially remained open ever since.

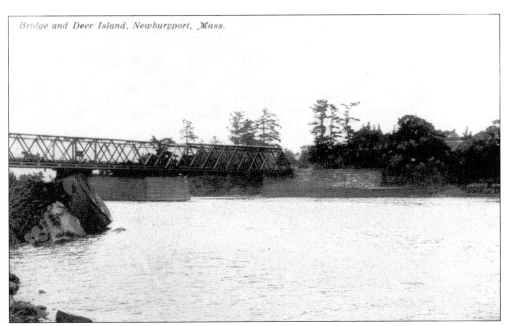

Also built by Timothy Parker in 1792, the Essex-Merrimac Bridge crosses the Merrimac River from Deer Island to Amesbury. The span from Deer Island to the center draw was a covered bridge more than a century ago and was believed to be the first covered bridge in the country. In 1882, a new iron bridge with a wooden deck replaced the decaying bridge, but a timber fire in 1964 destroyed that bridge. Dedicated in 1966, the new drawbridge required 40 minutes for eight men to manually open and close the draw for a waiting vessel. In 1973, a motor was furnished that would complete the task in 3 minutes.

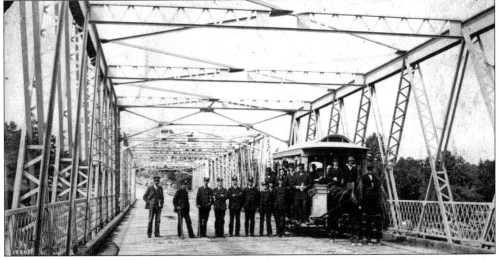

Shown here are horse and trolley conductors and drivers of the Haverhill and Amesbury Street Railway and the Newburyport and Amesbury Horse-Car companies. In the winters, highway personnel often came to blows when one company cleared its tracks by blocking the other's track. This often happened repeatedly in the same day—delaying services several hours as snows were recleared. On occasion, men were known to wet the snows covering the tracks of rival companies until it froze solid.

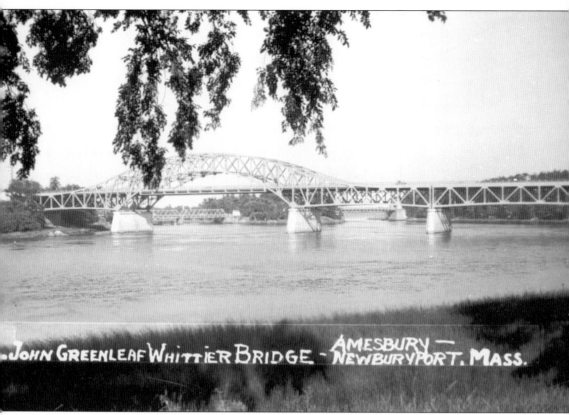

JOHN GREENLEAF WHITTIER BRIDGE - AMESBURY — NEWBURYPORT. MASS.

The John Greenleaf Whittier Memorial Bridge was built in 1951, opened in 1954, and carries Route 95 over the Merrimac River from Newburyport to Amesbury. The bridge was a replacement for the aging Route 1 drawbridge in downtown Newburyport. It is the youngest (and shortest at 1,346 feet) of three swinging deck bridges in Massachusetts, the others being the Sagamore and Bourne bridges leading to Cape Cod. It featured a wide sidewalk that faced the picturesque Chain Bridge basin of the Merrimac River, as well as a motorist rest area on the east side of the Newburyport bank, but road widening projects and public safety concerns in the 1970s triggered the removal of these amenities.

Two

POINT SHORE

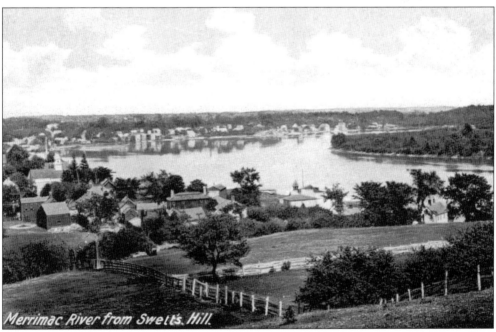

Merrimac River from Swett's Hill.

It is hard to imagine a more exquisite vista from anywhere in the world. The Merrimac River Valley offers a view of magnificent times of season that make harsh New England weather worth any ordeal. This scene from high on Swett's Hill off Merrimac Street has probably not been seen in a century. Virtually all of the open areas of old Amesbury are covered in tall trees, and the people who saw them have long left us. At the left in the scene is the roof and steeple of the Union Congregational Church, and directly above the S of Swett's, you can see the location of Lowell's Boat Shop on the far bank of the river.

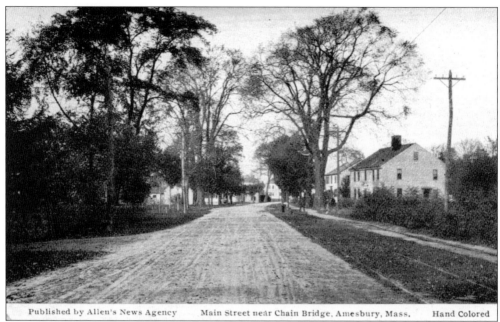

This is a view of Main Street in Amesbury near the turn of the century, about a quarter mile from the Essex-Merrimac Bridge. There have been so many beautiful Colonial homes lost to fire and the ages that it is hard to identify the homes in old cards and photographs, but the home at the right appears to be 480 Main Street.

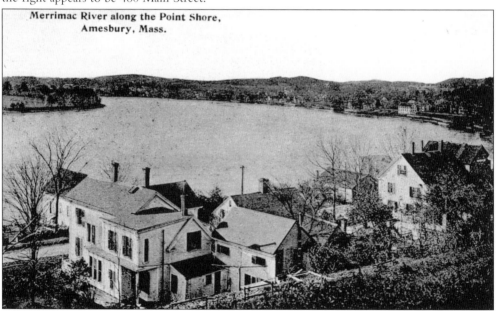

Merrimac River along the Point Shore,
Amesbury, Mass.

This is a view taken from atop Crumb Hill of the Merrimac River basin. Many boat shops were located along the banks at one time. The home to the front right is thought to be 462 Main Street, which would put Lowell's Boat Shop directly across the street and partially obscured. In the late 18th and early 19th centuries, there were so many boatyards that it was often difficult to walk or drive a horse and carriage along Main Street because of all the lumber sticking out into the road. Today, only Lowell's Boat Shop remains.

Merrimac River

Main Street and Point Sho
Amesbury, Mass.

Published by Palmer's 5 and
Cent Store.

In the early 1900s, postcards were intended to send a scene through the mail and were not for messages. The back of the card could be used only for addressing and could contain no message. This is why so many turn-of-the-century cards have writing on their face. To increase sales, some publishers provided a bit of extra white space on the side of the photograph for the sender to squeeze in a few words, as seen here.

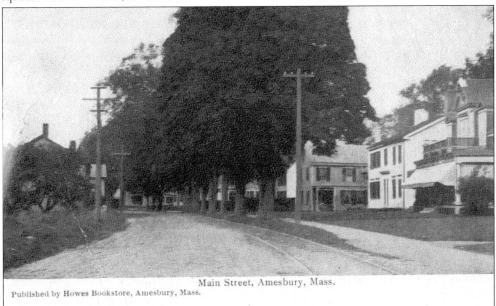

Main Street, Amesbury, Mass.

Published by Howes Bookstore, Amesbury, Mass.

The street along Point Shore is called Main Street; in earlier times, it was called River Street and was referred to as "the road leading from the Powow River to the Essex-Merrimac Bridge." The street still separates the waterfront from the old residential neighborhood established in the 18th century.

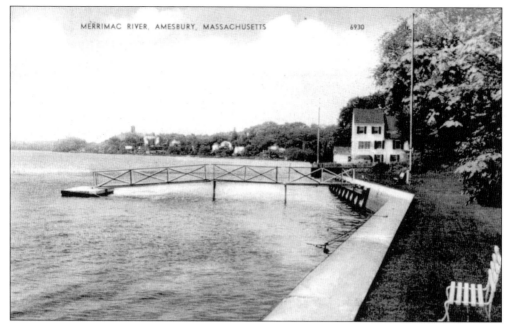

This view of 391 Main Street shows one of the many private boat docks along the Point Shore area. The dock construction has to allow a large up-and-down motion to accommodate the tides of the Merrimac River. Due to the incredible currents and ice floes of winter, docks must be removed.

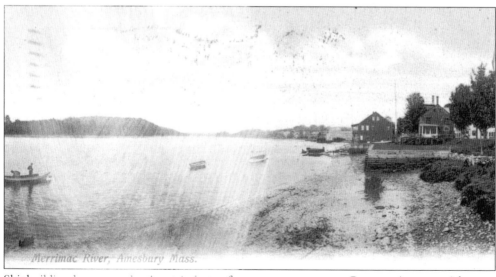

Shipbuilding became a dominant industry for numerous reasons. Construction materials were readily available, the water was deep and calm, and the shoreline was unsuited for agriculture and naturally sloped (allowing for the easy launching of new vessels). It has been noted that at the height of business, an estimated 2,000 ship carpenters, caulkers, and other workers were employed along Main Street in the yards of Salisbury and Amesbury, and the region launched well over 600 vessels in the 50- to 800-ton size.

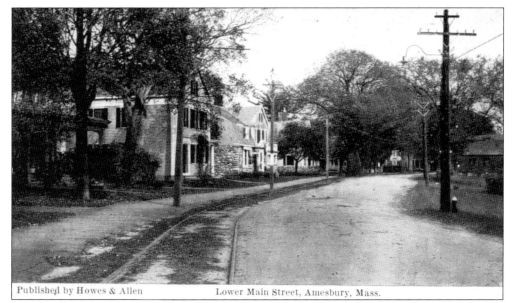

Published by Howes & Allen Lower Main Street, Amesbury, Mass.

Point Shore has the feel and quality of a mercantile village of the pre-industrial era. Many of its residences date back to the 1700s. It is an area almost frozen in time, with remarkably few intrusions. Recent efforts to renovate and restore Amesbury have made exceptional considerations to keep the area true to its period of development. At the left in the photograph are 404 and 406 Main Street—two houses that have changed little since they were built.

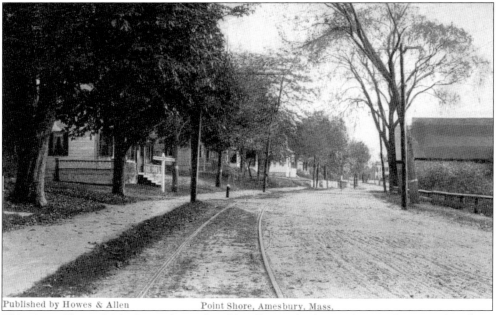

Published by Howes & Allen Point Shore, Amesbury, Mass.

This view of lower Main Street shows the old trolley tracks that used to run between Amesbury and Newburyport. An interesting tale concerns the maiden trek of the horse-drawn trolley. It took several hours to travel the distance that today takes only several minutes because the trolley kept derailing. Every time the train derailed, the horses would be unhitched and the passengers would have to lift and coax the trolley back onto the tracks. There were additional horses kept along the rails to help when the trolley encountered a steep incline or a difficult curve.

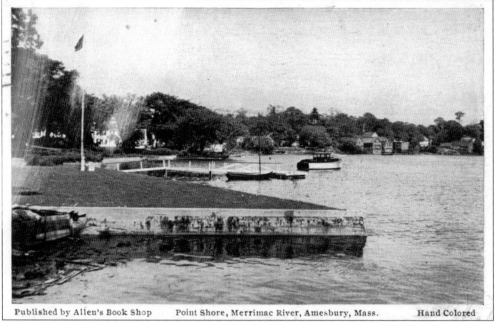

Published by Allen's Book Shop Point Shore, Merrimac River, Amesbury, Mass. Hand Colored

Nestled in the trees, 417 Main Street can barely be seen. To the right, you can see Lowell's Boat Shop, the last surviving boatbuilding enterprise on a waterfront that was once crowded with shipyards and boat shops. Most of the houses near the Lowell shop were built for shipbuilding and boatbuilding families who worked on the nearby waterfront.

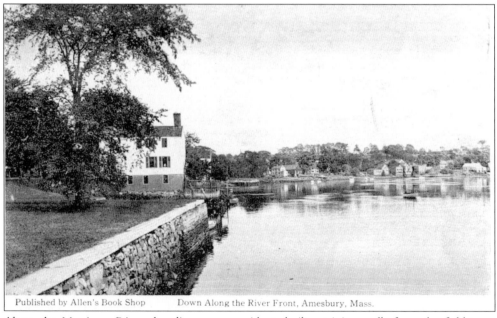

Published by Allen's Book Shop Down Along the River Front, Amesbury, Mass.

Along the Merrimac River shoreline, many residents built retaining walls from the fieldstones prevalent in the area to protect their property from the tides. A fine example is shown in this snapshot. Little restoration work has ever been done to these walls since they were first constructed.

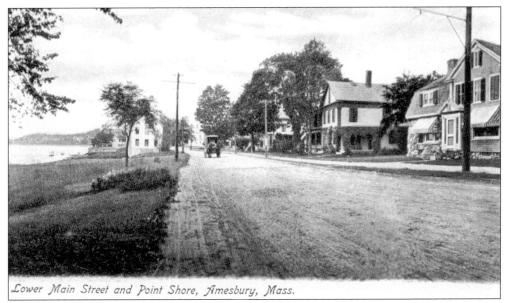

Lower Main Street and Point Shore, Amesbury, Mass.

During the Federalist period (1775–1830), the greatest increase in population occurred in the neighborhoods affiliated with the shipbuilding trade. Amesbury has a rich heritage of residences remaining from this era, with a total of 77 Georgian- and Federal-style dwellings. The Point Shore has 37 residences from this era, and the Ferry District (west of the Powow River) has a total of 11.

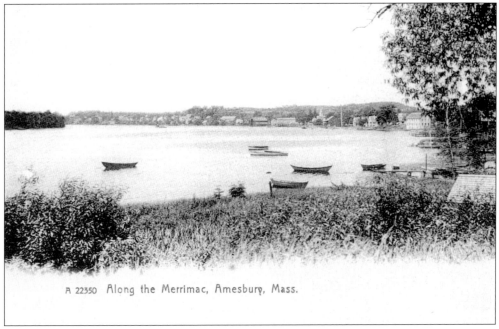

A 22350 Along the Merrimac, Amesbury, Mass.

Amesbury is fortunate to have more than four miles of riverfront along the Merrimac River. Some of the landscape on the opposite shore of the river in Newburyport and in Newbury is protected in public ownership. Much of the Merrimac River shoreline of Amesbury's Point Shore area was developed with beautiful and sturdy houses—a legacy of the shipbuilding era in the 18th and 19th centuries.

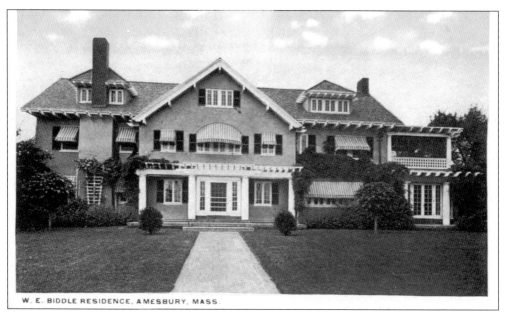

W. E. BIDDLE RESIDENCE, AMESBURY, MASS.

This was a mansion of William "Billy" Biddle of the Biddle and Smart Carriage Company of Amesbury. One of the largest producers of carriages in the world and famous for their buckboard wagons, they grew to occupy nine factory buildings by 1880. In 1915, Biddle and Smart was the absolute largest builder of automobile bodies in the world. Biddle contracted this Point Shore home at 372 Main Street—one of the most beautiful homes in Amesbury.

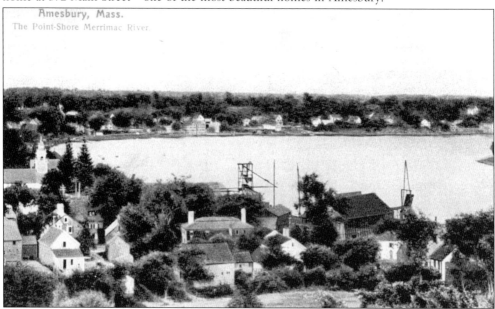

Amesbury, Mass.
The Point-Shore Merrimac River.

Near the site of the scaffolding in this picture was the location where Pres. George Washington landed when he visited Amesbury on his New England tour in October 1789. He crossed the Merrimac River from County Road in Newburyport and disembarked at Pearson Tavern Dock—actually several houses west of this site. A plaque set into a bolder commemorates the landing but was relocated to the front lawn of the nearby water-treatment plant as hectic town-landing activities threatened its welfare.

Point Shore, showing mouth of Powow River, Amesbury, Mass.

In May 1918, three out-of-service fire alarm call boxes helped to cause a devastating fire at the Otto Kranz Coal Wharf, shown here and located where Alliance Park is today. By the time the town fire hose responded, Main Street between the now-blazing coal wharf and the Union Congregational Church was so hot that it could not be passed to get to the hydrant on the other side. The hose was forced to take a several-mile trek to respond to the fire from the opposite direction. By the time the hose was in place, the property was a total loss and there was extensive damage to the frontage of the church.

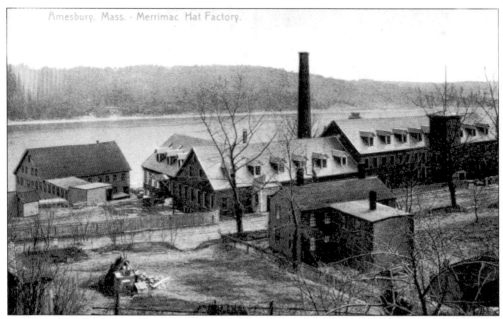

In 1877, the Merrimac Hat Company's hats were considered the best on the market. In December 1872, the company announced that the past six months had seen sales of almost 22,000 hats. In the next two years, production had increased to more than 41,000 hats, which propelled the construction of this new plant. Renovations are under way to restore and convert some of the former hat factory buildings into a mixed residential-commercial project. In 1987, the 24 structures associated with the Merrimac Hat Company were given a determination of eligibility to be on the National Register of Historic Places.

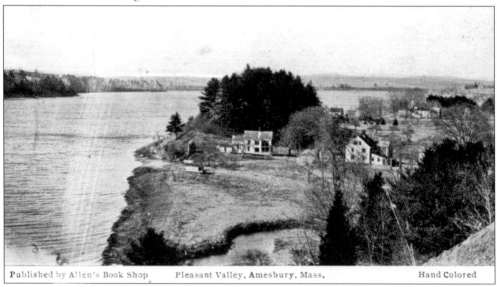

Published by Allen's Book Shop Pleasant Valley, Amesbury, Mass. Hand Colored

In 1736, the most noted event of the year was the building of the new road along Pleasant Valley. The owners along the road agreed to donate land for the purpose of travel convenience and to encourage trade. One of the most beautiful drives in Amesbury and Merrimac is along the banks of the river through Pleasant Valley. Poet John Greenleaf Whittier strode along these paths often for inspiration.

This magnificent and tranquil artist's view was taken beside a majestic elm tree that no longer adorns the property at 355 Main Street, east of Alliance Park at Point Shore.

This is a *c.* 1930 photograph of the above tree, taken from Alliance Park. The blue spruce at the left, only several feet tall in this photograph, is now towering at more than 100 feet. The expanse of lawn is now framed with trees and perennial plants.

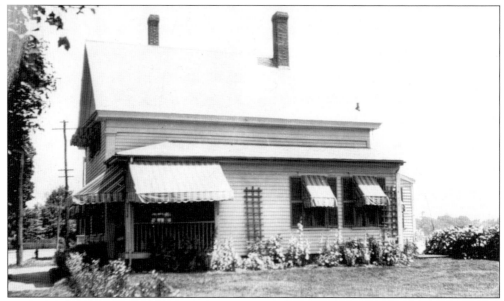

In 1930, when this photograph was taken, John and Anne Hession had lived in this home for eight years and had just brought home their little girl, Mary Jane. Along the side of the house, Anne grew a magnificent rock garden with a breathtaking array of perennial flowers, and to the right is a Concord grape vine that made the air very fragrant and sweet on hot days.

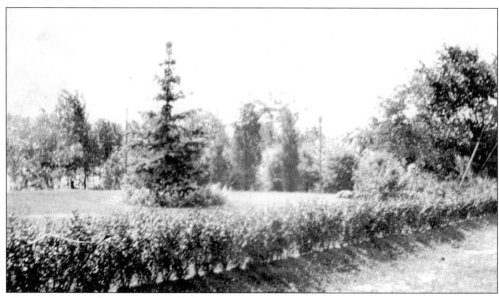

This 1920s view from Main Street faces west toward what is now Alliance Park. The area had yet to be developed as a park and still showed scars and ruins from the Otto Kranz Coal Wharf fire some 10 years earlier. Knowing the park now, it is hard to believe that thicket of trees was ever at that location.

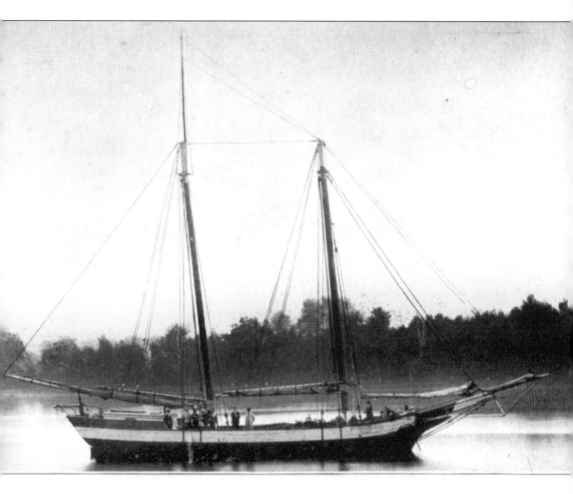

The Schooner "Polly." Built at Amesbury in 1805.

Amesbury's *Polly* was not a privateer, as is commonly reported. In 1905, *Polly* returned to Amesbury for its 100th birthday, but the stories it was honored for were not of this vessel. This ship was built by David Currier, a descendant of Amesbury founding citizen Richard Currier, and was likely named after David's wife, Polly Rowell. Built on the Powow River, *Polly* weighed 60 tons and was 60 feet long. The often told history of *Polly* is actually of two privateers of the same name that served in the War of 1812. *Polly* met its end in 1918, broken up for firewood in a Quincy shipyard.

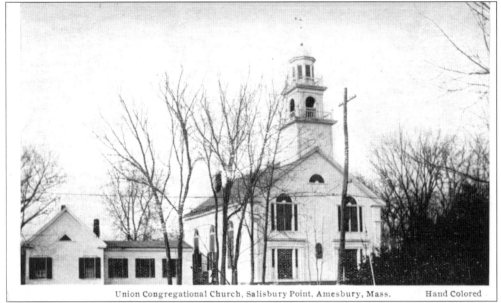

Union Congregational Church, Salisbury Point, Amesbury, Mass. Hand Colored

In September through December 1835, the Union Congregational Church was built at what was known as Webster's Point. It was designed by area shipbuilders during their "slack season." The roof is actually constructed as an inverted hull, with ships ribs tying the beams and rafters together. The 10-foot-long granite stones on which the church rests measure 3 by 3 feet. Major interior revisions were made in 1873, and most are still in use today. In 1936, the great flood damaged the original organ beyond repair, and a Hammond organ has been in use since 1955.

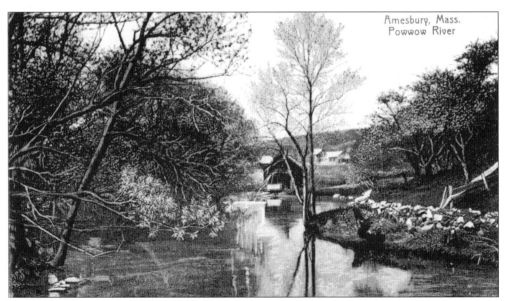

Amesbury, Mass.
Powwow River

The first vessel to be built and launched on the Merrimac River was constructed on the Powow River by Caleb Peter in 1639. Amesbury is fortunate to have several miles of the Powow River course through town, with some stretches of the river having considerable importance in the history of the development of the town. Ships used to be built on the Powow as far up as Aubin Street on the northwest corner of the (old) post office.

34

Three
NOTABLE
NEIGHBORHOODS

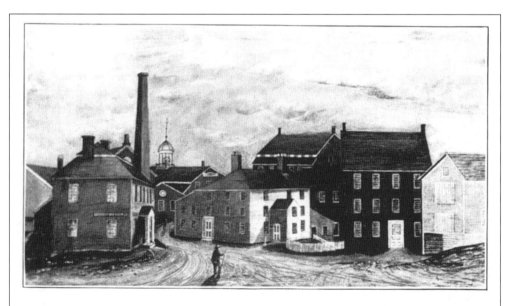

VIEW OF WATER STREET FROM MARKET SQUARE, AMESBURY, 1853.

This artist's rendition of Water Street as seen from Market Square in 1853 takes considerable artistic license, as it is difficult to identify anything in the painting. The solitary figure seems out of place compared to any photographs of this period, which show the Market Square area as the frenetic hub of Amesbury's activities.

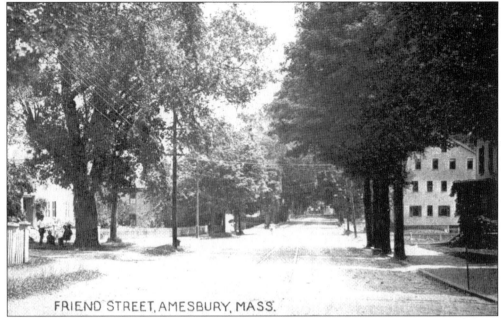

FRIEND STREET, AMESBURY, MASS.

This view of Friend Street looks west toward town. The photographer of this series of postal images appears to have gone to great lengths to find a position on a commonly traversed street to make it difficult to recognize, but this photograph shows the area where the town park is now located on the right.

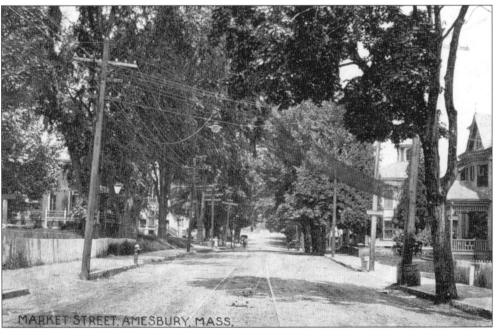

MARKET STREET, AMESBURY, MASS.

A view of Market Street faces north toward New Hampshire. The trolley tracks located in the middle of the street must have caused many difficulties for horse-and-buggy operators to pass their carriages along Market Street at the time. Note the volume of telephone wires—the poles appear to be bending to the weight of the cable.

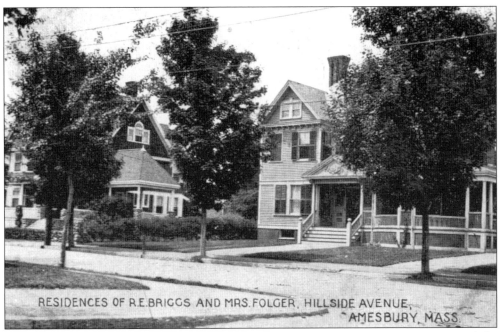

RESIDENCES OF R.E.BRIGGS AND MRS.FOLGER, HILLSIDE AVENUE, AMESBURY, MASS.

Pictured are the Emond, Kinsella, Miller, and Murray residence, at 1 Hillside Avenue, and the Dowd home, at 3 Hillside Avenue. Both houses have been meticulously maintained. As shown in the card, the houses are on the west side of Hillside Avenue-Route 150. North is to the right.

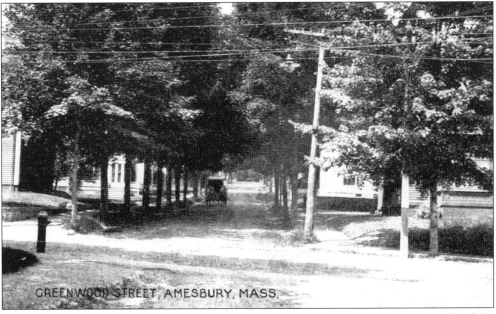

GREENWOOD STREET, AMESBURY, MASS.

This photograph of Greenwood Street faces east toward Hillside Avenue. Virtually all of the landmarks in this view are gone or have been renovated to a glimmer of this period, but you would be hard pressed to find an Amesbury resident who could not steal a glance at this scene and recognize it as Greenwood Street. Thickly positioned trees have formed a canopy over the street for over a century.

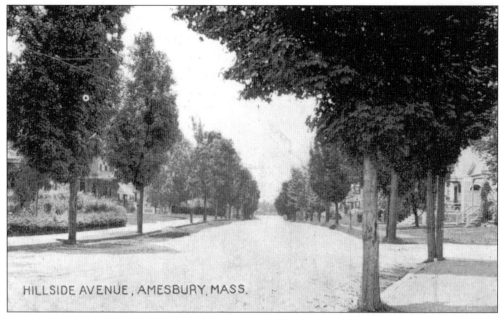

HILLSIDE AVENUE, AMESBURY, MASS.

The house seen just beyond Estes Street to the right in this print is 7 Hillside Avenue, which still stands as a beautifully restored Victorian home. The photographer of this postcard is facing south down Hillside Avenue.

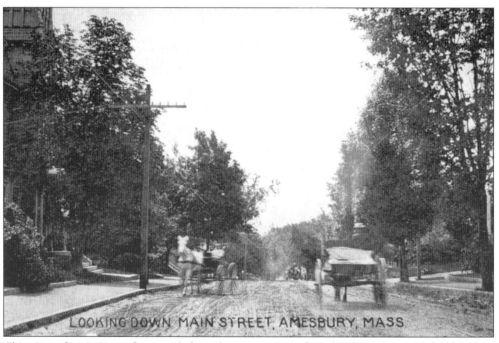

LOOKING DOWN MAIN STREET, AMESBURY, MASS.

This view of Main Street faces south from the intersection of Sparhawk, Main, and School Streets. The horse-drawn buggies in the photograph are kicking up enough dust to bury the trolley tracks. Shown at the left is the fabulous Jacob R. Huntington Victorian home. Later in its life, it was used as a Knights of Columbus home and, in 1968, was razed in connection with the Heritage Towers Apartments building project.

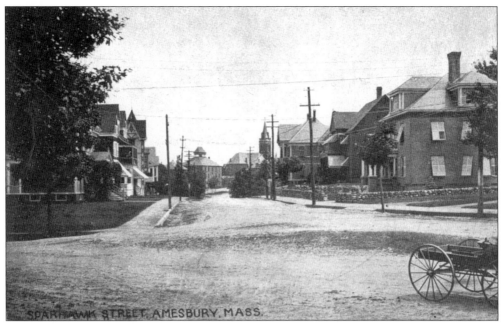

Sparhawk Street is shown in a view looking from the intersection of Highland, Sparhawk, and Greenleaf Streets. At the right is 52 Sparhawk Street, which is located directly across from the former parsonage of the Main Street Congregational Church and now houses the offices of attorney Charles E. Schissel. In the distance, you can clearly see the steeple of St. Joseph's Church and the belfry of St. Joseph's Parochial School. Trees now obscure this whole view.

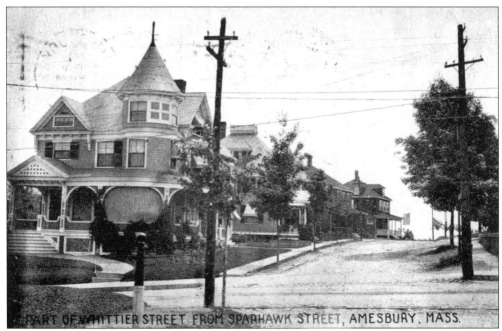

Pictured here is 44 Sparhawk Street. The porch is considerably different and the house is almost completely obscured by trees, but this fine Victorian remains as handsome a building as it was when it was new.

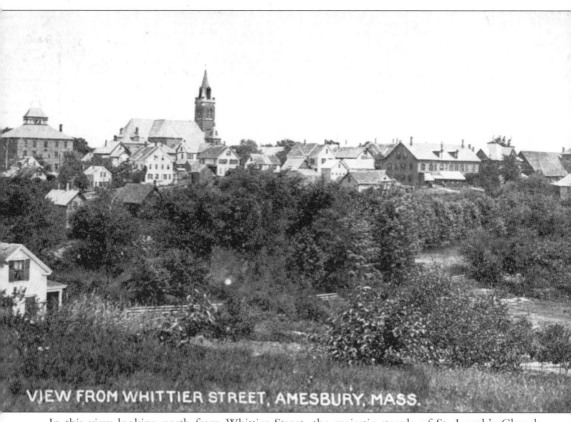

VIEW FROM WHITTIER STREET, AMESBURY, MASS.

In this view looking north from Whittier Street, the majestic steeple of St. Joseph's Church dominates the landscape and keeps a protective presence over the town. The most remarkable thing to note about this series of photographs is the absence of tall trees. This view would be impossible to duplicate today.

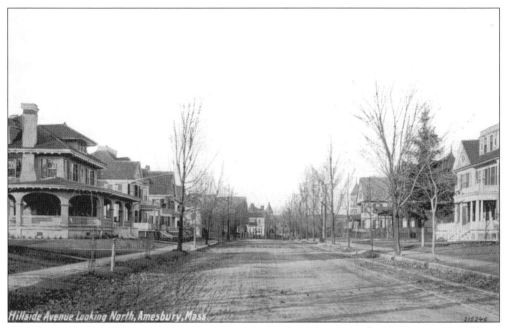

Hillside Avenue is shown in a view facing north. To the left is 15 Hillside Avenue, across from 12 Hillside Avenue. No. 15 is virtually unchanged since the turn of the century, when this photograph was taken. No. 12 has lost its second-floor balcony and wraparound front porch to renovations over the decades.

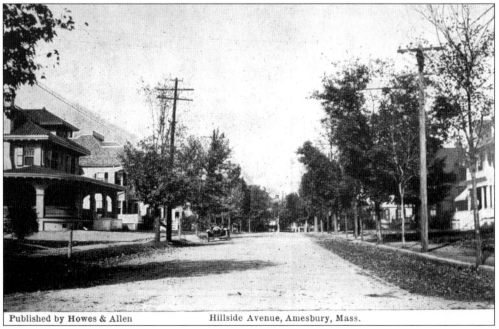

This is virtually the same photograph as above, taken some 10 to 20 years later. The roadster in the middle of the scene most likely has a wooden body made in one of Amesbury's many auto body factories. The most remarkable difference between these two photographs is the absence of telephone poles in the earlier shot.

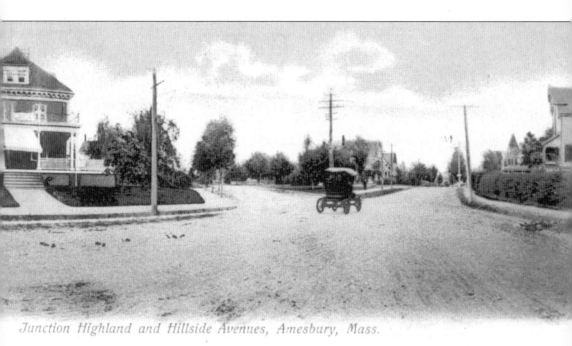

Junction Highland and Hillside Avenues, Amesbury, Mass.

ublished in Germany by Howes Book Store, Amesbury, Mass

Pictured here is 58 Sparhawk Street. At the center rear of the photograph is now the Paul C. Rogers Funeral Home, and at the right is 55 Sparhawk Street. Summer D. Goldsmith Park is at the center of the junction directly behind the horseless carriage. Longtime residents will notice the absence of roadway islands and how the area was created to be sprawling for the purpose of promenading about the neighborhood.

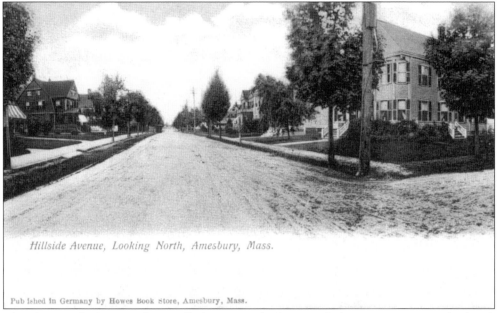

Hillside Avenue, Looking North, Amesbury, Mass.

Published in Germany by Howes Book Store, Amesbury, Mass.

The photograph claims to show Hillside Avenue, looking north, but not one existing landmark can be identified in the scene. It is important to note that many postcards were printed and published in Europe—Germany was predominantly responsible for many of Amesbury's cards—and the employees of the printing companies would be hard pressed to verify a location in the event of a jumble of photographs. This is one of the reasons that many early postcards contain misspellings of common words.

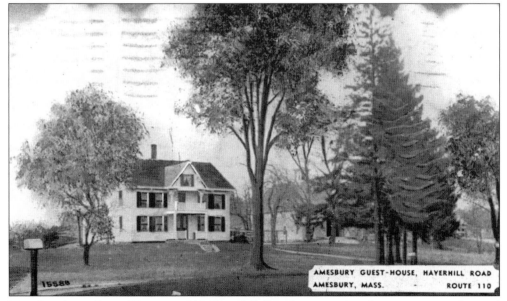

AMESBURY GUEST-HOUSE, HAVERHILL ROAD
AMESBURY, MASS. - ROUTE 110

The Amesbury Guest House, at 118 Haverhill Road, was an inn for summer travelers and featured the slogan "Make our house your vacation headquarters." It featured clean, cool, and comfortable rooms and was located on Route 110, the main route to all beaches. Little has changed about the house except for the removal of the front porch and balcony. The postcard indicates a telephone number to call, "Amesbury: 132-5."

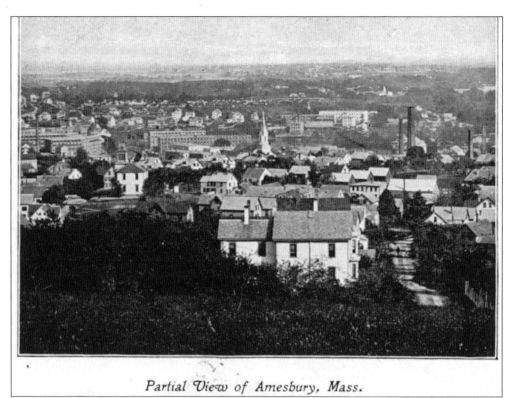

Partial View of Amesbury, Mass.

This bird's-eye view looking toward the Market Square section of Amesbury was most likely taken from Powow Hill (commonly called Po Hill) on a beautiful and bright afternoon. The Market Street Baptist Church steeple can be seen in the center of the photograph.

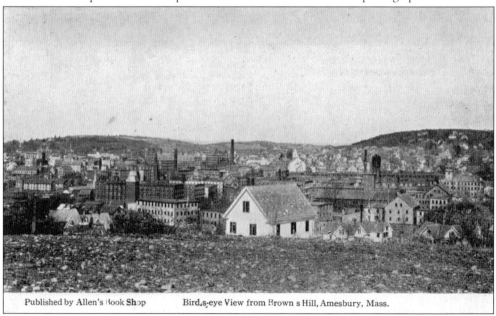

Published by Allen's Book Shop Bird,s-eye View from Brown s Hill, Amesbury, Mass.

This scene of Amesbury's carriage district from Brown's Hill shows how the town is nestled in a valley of several hills. Notice the absence of tall trees in the landscape.

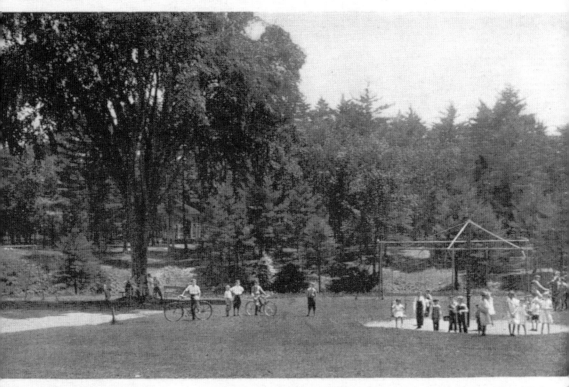

Published by Allen's Book Shop Amesbury Park, Amesbury, Mass. Hand Colored

The Amesbury Town Park playground was originally centered on a massive and beautiful elm tree, seen here, which sculptor Leonard Craske called "the Most Beautiful Tree in America." Hurricane Carol tore its roots from the ground and destroyed the tree on August 31, 1954. The park, located between Friend and Highland Streets, now features baseball diamonds, swings, playground structures, and a skateboard park. You can also see the bandstand nestled in the trees in the background.

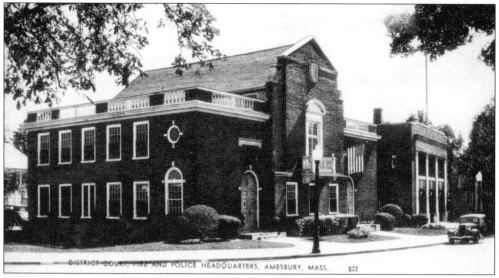

DISTRICT COURT, FIRE AND POLICE HEADQUARTERS, AMESBURY, MASS. 822

Pictured, from left to right, are the Amesbury District Court, the police headquarters, and the Central Fire Station on School Street. Recently, an addition connected the police and fire stations, but prior to the expansion project, these buildings remained virtually unchanged for decades. The Central Fire Station was built in 1928 for $60,000. The town hall annex was the original central fire station. The original police station was located in the town hall.

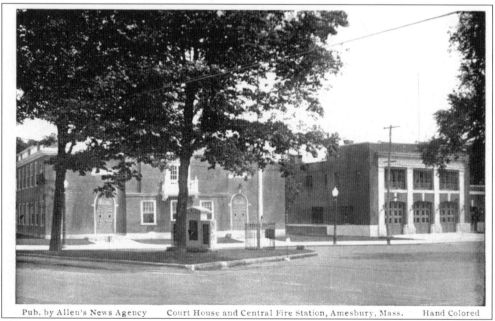

Pub. by Allen's News Agency Court House and Central Fire Station, Amesbury, Mass. Hand Colored

The small park at the junction of Friend and School Streets is George McNeill Square, dedicated to the memory of George E. McNeill, one of the great leaders of organized labor in New England. McNeill's grandson erected the flagpole and bronze fence in his grandfather's memory. The granite monument in the center was presented to Amesbury in memory of E.P. Wallace and members of Post No. 122 of the Grand Army of the Republic. Wallace was a crippled shoemaker who worked within his means to support the antislavery movement and help equip the Union army for the Civil War.

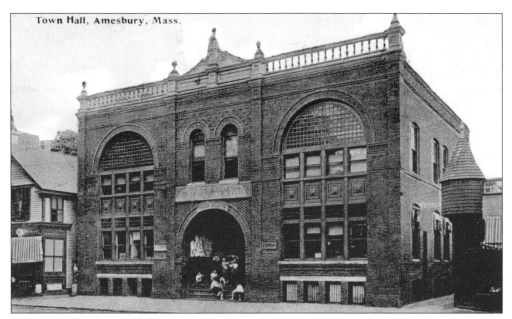

The Amesbury Town Hall, at 62 Friend Street, was dedicated as the new town armory on Thanksgiving Eve 1888 by Company B, "Bartlett's Rifles," with by a grand military ball. It was built on the site of the burned Kelly Opera House. It contains a large drill hall that could be used for dances and originally had a false floor for drill practice that could be removed for formal events. Built for $18,000 from Amesbury bricks, it was once considered the finest armory ever built in Massachusetts.

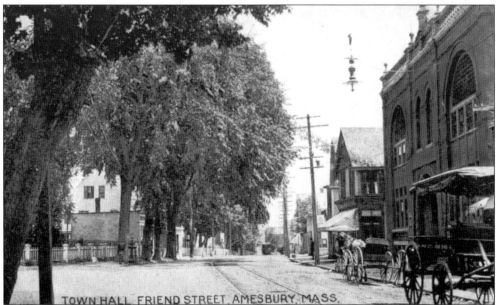

TOWN HALL FRIEND STREET, AMESBURY, MASS.

This wonderful shot looking east down Friend Street is quite reflective of the days gone by. The several beautiful and broad elm trees casually drape the street as two buggies are parked at the town hall on the right. The trolley tracks bring to mind the struggles of horses pulling a loaded trolley carriage up the steep hill. The town hall still looks exactly the same as it did when it was built, but much of the interior has been renovated.

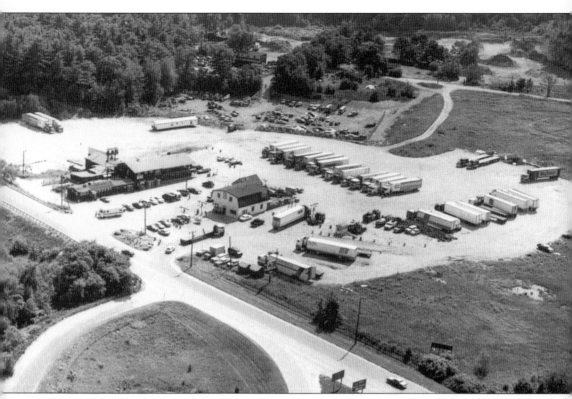

Trader Alan's Truck Stop was bursting with activity throughout the 1960s, 1970s, and 1980s but closed operations in the 1990s, and the property has been abandoned and extensively vandalized. In its heyday, Trader Alan's 24-hour full-service truck stop featured diesel fuel, gasoline, a service station, an early Store 24 style of travel store, a diner, a 16-room motel, and provided trucking permits and a loading service. It was one of the first establishments in the area at the time to use the new "Mastercharge."

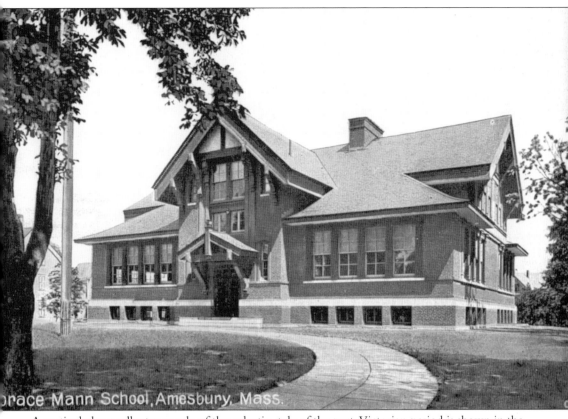

Horace Mann School, Amesbury, Mass.

A particularly excellent example of the eclectic style of the post-Victorian period is shown in the Horace Mann School at 10 Congress Street, which was dedicated on September 3, 1908. Beginning in 1967, the school was closed for three years due to the new elementary school absorbing its students in grades one through four. The school reopened in 1970 with 150 students after a new fire sprinkler system was installed and esthetic renovations were made. The school continues to serve the community well.

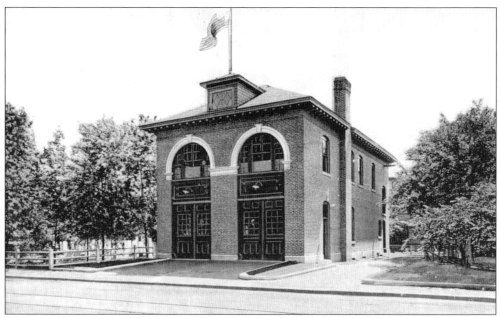

A horse-drawn fire apparatus truck was bought in 1901, and the Elm Street Fire Company was born. It was a volunteer company until the station was built in 1909 for $9,500 on the former site of the Corner School and dedicated on March 1, 1910. Called Hose No. 3 for many years, the building is now titled Forestry 2, Engine No. 3.

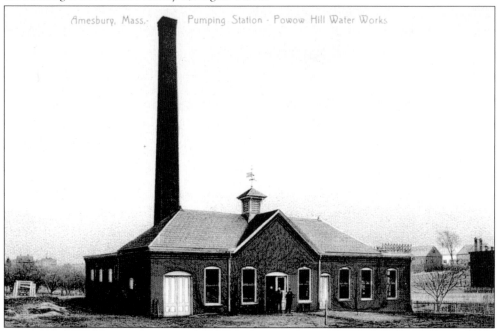

In 1883, the pumping station was built to provide ample pressure for firefighting in Amesbury. It was supplied with water from a tank on Powow (Po) Hill. In one of the worst fires in Amesbury's history, the Amesbury Opera House fire could not be extinguished due to low water pressure. The person in charge of water pressure was away for the weekend and did not delegate his duties.

Four
MONUMENTS
TO THE PAST

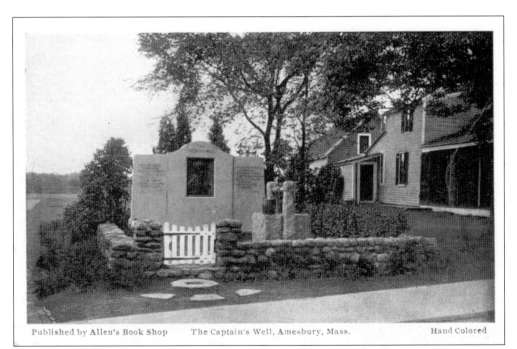

The Captain's Well is the subject of one of John Greenleaf Whittier's best-known poems, which speaks of the legend of Capt. Valentine Bagley's shipwreck off the coast of Arabia and his vow to dig a well if he survives. The poem is not historically accurate. Bagley was not a captain and was only 19 years old at the time. Bagley later ran a tavern in his family's home that still stands near the well. "Bartlett's Corner" is the location of the well described in the poem, and the well was actually dug by a grandson of Anthony and Susannah's Colby's daughter Mary.

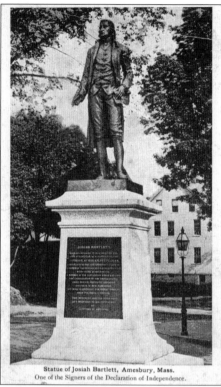

Statue of Josiah Bartlett, Amesbury, Mass.
One of the Signers of the Declaration of Independence.

As you enter Amesbury at the intersection of Main, Sparhawk, and School Streets, there stands a bronze and granite statue by sculptor Karl Gerhardt erected to the memory of Josiah Bartlett. The statue is engraved with the following text: "Born at Amesbury Massachusetts, Died at Kingston New Hampshire. Patriot, scholar, statesman, a delegate to the Continental Congress, a signer of the Declaration of Independence, chief justice, president and first governor of New Hampshire. Not more illustrious for public services than for private values."

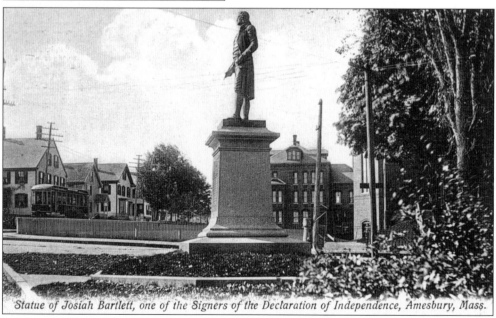

Statue of Josiah Bartlett, one of the Signers of the Declaration of Independence, Amesbury, Mass.

The Josiah Bartlett memorial statue was dedicated on July 4, 1888, and rededicated on July 4, 1967, when the statue was repositioned to point east and downtown, from facing toward his birthplace site, which was a mile south on Main Street. A boulder with bronze marker at 276 Main Street in Amesbury marks the site of the modest house in which Josiah Bartlett was born. The home was razed *c.* 1877 to make room for the Bartlett Home for Aged Women.

Josiah Bartlett was always "Amesbury's favorite son"—signer of the Declaration of Independence and the Articles of Confederation. A vote was taken concerning independence from Britain, and it was agreed that the northernmost colony would begin the voting. Thus it was that Josiah Bartlett cast the first vote in favor of the American Revolution. As with signing the Declaration of Independence, these documents were symbols to high acts of treason, punishable by death if the colonies lost the struggle.

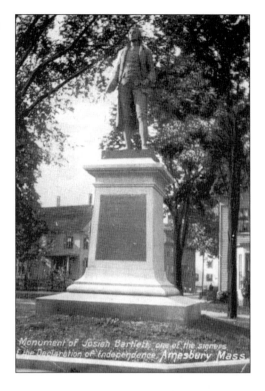

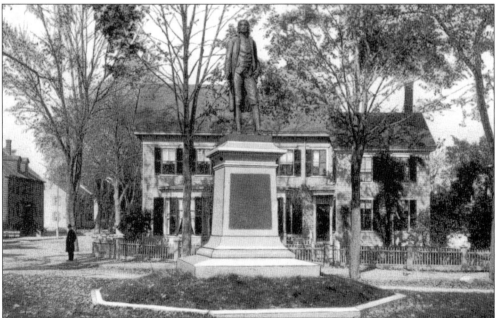

Huntington Square, where the statue is situated, was named after Jacob R. Huntington, a native of Amesbury and the donor of the statue, who was considered the father of the Amesbury carriage industry. He presented the statue honoring Bartlett to the state of Massachusetts in 1888. The Alexander M. Huntington house (c. 1884), shown in the background, was located on Main Street next to the Amesbury Public Library. Regrettably, it was razed in the 1970s.

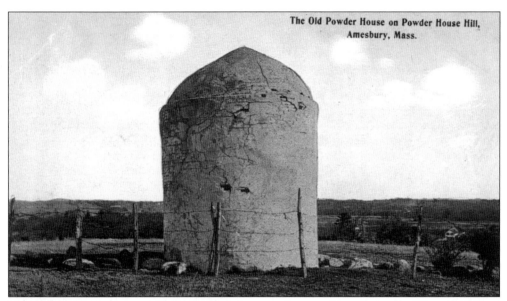

The Old Powder House on Powder House Hill, Amesbury, Mass.

The powder house was used for the storage of arms and ammunition during the War of 1812 and was built in 1810. The Amesbury Improvement Association preserved it to its present condition, and the property is now privately owned. Beginning in Native American times, settlers built powder houses where arms and ammunition of the Colonial militia were stored. Only seven of these military storage locations remain in Massachusetts, and Amesbury's is located off Madison Street on Powder House Hill. This virtually treeless scene is completely different from the lush forest that has grown in the area.

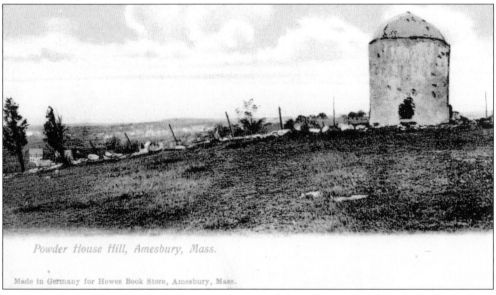

Powder House Hill, Amesbury, Mass.

Made in Germany for Howes Book Store, Amesbury, Mass.

During the Revolutionary War (1775–1783), most of the soldiers came from New England. In 1774, the British army planned raids to steal any stores of guns and ammunition and knew of the powder stored in Amesbury's powder house, which was thought to be enough to blow up the whole Merrimac Valley if it detonated. Paul Revere rode to Amesbury via Newburyport to deliver warnings to be on guard against the raids. As we were still English subjects at this time, if caught, Revere would have been hung as a traitor to the crown.

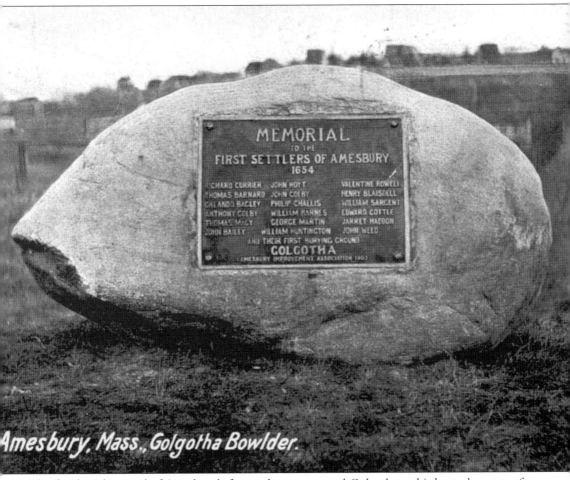

MEMORIAL
TO THE
FIRST SETTLERS OF AMESBURY
1654

RICHARD CURRIER	JOHN HOYT	VALENTINE ROWELL
THOMAS BARNARD	JOHN COLBY	HENRY BLAISDELL
ORLANDO BAGLEY	PHILIP CHALLIS	WILLIAM SARGENT
ANTHONY COLBY	WILLIAM BARNES	EDWARD COTTLE
THOMAS MACY	GEORGE MARTIN	JARRET HADDON
JOHN BAILEY	WILLIAM HUNTINGTON	JOHN WEED

AND THEIR FIRST BURYING GROUND
GOLGOTHA
AMESBURY IMPROVEMENT ASSOCIATION 1903

Amesbury, Mass., Golgotha Bowlder.

The first burial ground of Amesbury's first settlers was named Golgotha and is located on top of the Macy Street hill, overlooking the Powow River. History indicates that there are about 40 graves in the small plot marked by a memorial boulder placed on the site by the Amesbury Improvement Association. Its former owner, Gayden Morrill, donated the site to the town. The boulder is believed to been provided from the J.W. Huntington farm on Haverhill Road in Amesbury. To avoid disturbing Golgotha during the construction of Route 110 in 1928, the home and barn of Michael Hession, located across the street, were relocated.

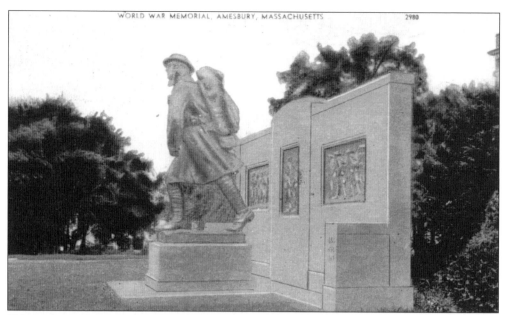

Shown here is Leonard Craske's *The Doughboy*—a tribute to the courageous Amesbury servicemen who fought in World War I. The statue is located on the front lawn of the Amesbury Middle School. It is shown here in front of the old Amesbury High School, which was destroyed by fire in 1964. Leonard Craske sculpted this statue (dedicated on Armistice Day, November 11, 1929) to honor all those who served in World War I and other wars. Throughout the years, many services to honor Amesbury's military would be held on this site.

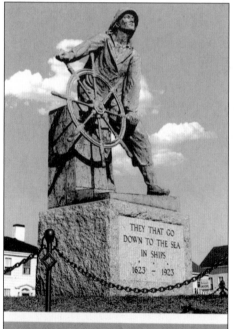

"They that go down to the sea in ships, that do business in great waters; These see the works of the Lord, and his wonders in the deep."

The Doughboy was fashioned by Leonard Craske, the same sculptor who created Gloucester's famous landmark sculpture, *The Fishermen's Memorial Statue,* also known as *The Man at the Wheel,* which is a memorial to fisherman lost at sea. Bearing the inscription "They That Go Down to the Sea in Ships," it was dedicated on August 23, 1925.

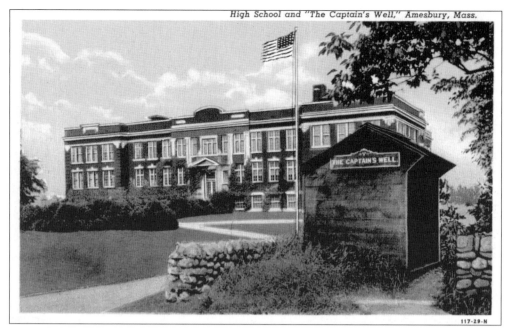

117-29-N

This scene shows the proximity of the original Captain's Well shelter to the old Amesbury High School, which was destroyed by fire in 1964. In addition to sheltering the original well, the simple wooden frame was used to conceal a green relay box, used by the mail carriers of the town.

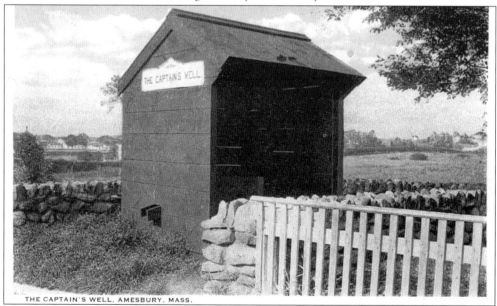

THE CAPTAIN'S WELL, AMESBURY, MASS.

Upon seeing the dilapidated condition of the Captain's Well one winter, former state senator James H. Walker's wife was passionately moved to finance the redesign, construction, and redrilling of the well to a more prestigious structure. Many artists submitted proposals, but sculptor Leonard Craske's simple and reflective design won out. On the day of the rededication of the well on July 25 1930, Pres. Herbert Hoover wired congratulations to the town of Amesbury on receiving such an admirable memorial. Originally dug in 1796, the well had been dry for more than 30 years until the reconstruction.

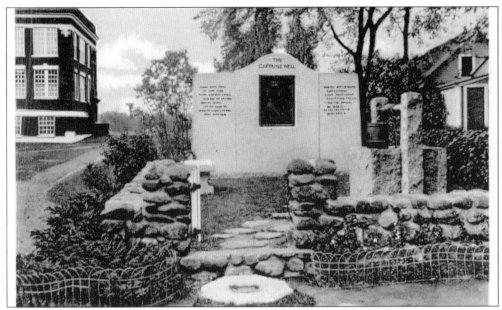

A bronzed bucket affixed to a granite well now houses a drinking water fountain fed by town water mains, and a bronze plate on the edge of the well commemorates the restoration of the site. There are three bronze panels mounted to a granite tablet behind the well. The engraved image on the middle panel is Capt. Valentine Bagley, and the two side panels present lines from Whittier's poem "The Captain's Well." Craske worked to harmonize the Captain's Well with the nearby *Doughboy* World War I memorial.

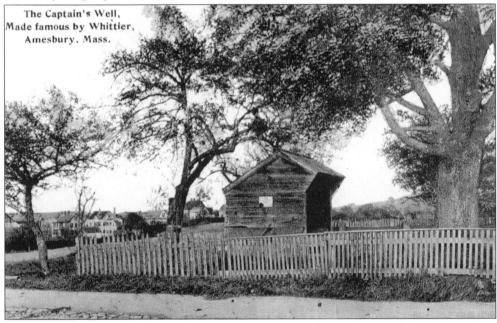

Capt. Valentine Bagley died at Bartlett's Corner on January 19, 1839. A seafaring man early in his life, his sufferings while castaway in the desert of Arabia were said to be "beyond the power of description." The last of his life was spent as a tavern-stand landlord. Writer Harriet Prescott Spofford has also made his well the subject of her poetry.

Five

AMESBURY'S WHITTIER

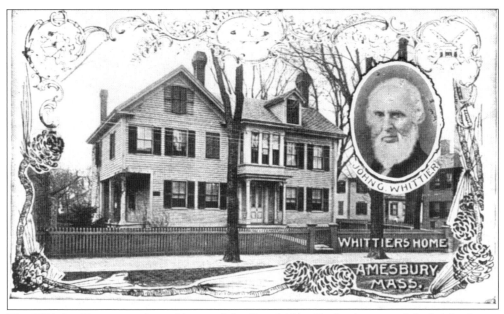

The Whittier Home was the residence of the famed New England poet and forthright slavery abolitionist from 1836 to 1892. It stands as a frozen snapshot of 19th-century life in New England. The house has been owned and maintained by the Whittier Home Association since 1918 and serves as a memorial to the poet and antislavery champion who made exceptional contributions to the life and literature of this country.

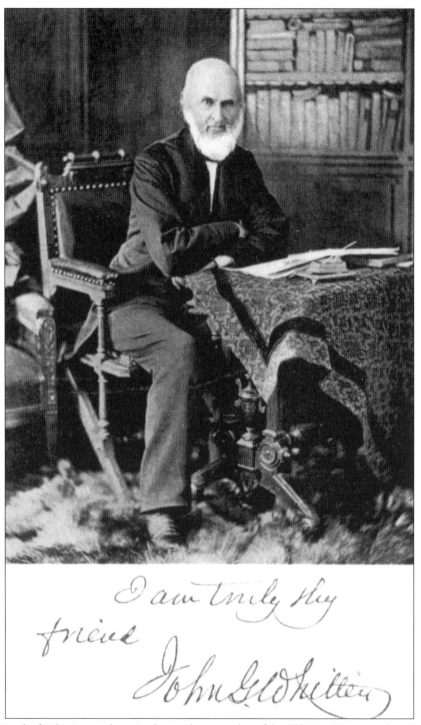

John Greenleaf Whittier was born in the southwest parlor of the Whittier Homestead in Haverhill. In 1831, he brought out a book of prose works, *Legends of New England,* and in 1866, the publication of "Snow-Bound" brought him financial comfort. Whittier's popularity continued into the next century, and he was considered one of the 19th century's best "fireside poets."

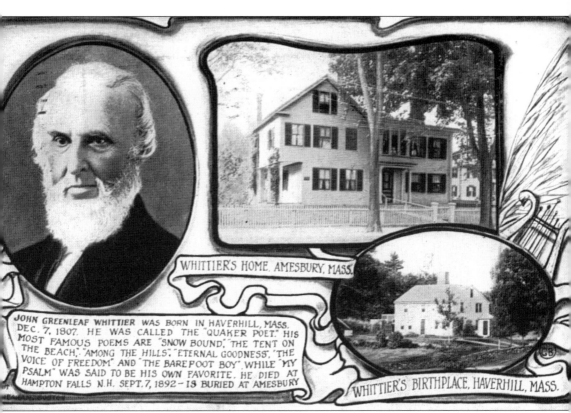

WHITTIER'S HOME, AMESBURY, MASS.

JOHN GREENLEAF WHITTIER WAS BORN IN HAVERHILL, MASS. DEC. 7, 1807. HE WAS CALLED THE "QUAKER POET." HIS MOST FAMOUS POEMS ARE "SNOW BOUND", "THE TENT ON THE BEACH", "AMONG THE HILLS", "ETERNAL GOODNESS", "THE VOICE OF FREEDOM" AND "THE BAREFOOT BOY", WHILE "MY PSALM" WAS SAID TO BE HIS OWN FAVORITE. HE DIED AT HAMPTON FALLS N.H. SEPT. 7, 1892 — IS BURIED AT AMESBURY

WHITTIER'S BIRTHPLACE, HAVERHILL, MASS.

In July 1836, Whittier (at the age of 29) and his mother, sister, and aunt came to Amesbury after the sale of their Whittier farm, which was nine miles away in East Haverhill. They moved into what was originally a one-story cottage on 86 Friend Street in Amesbury, with four rooms on the ground floor and a chamber in the attic, for about $1,200. In 1840, Whittier made his residence in Amesbury permanent.

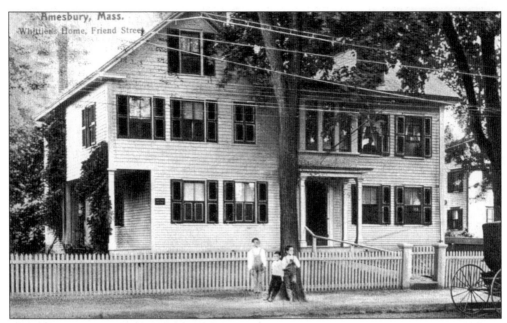

The Whittier Home was the home of the famed New England poet and slavery abolitionist from 1836 to 1892. It stands as an accurate segment of 19th-century life in New England. Between 1936 and 1940, Whittier was away from home most of the time, engaged with duties as secretary of the Anti-Slavery Society in New York and as the editor of the *Pennsylvania Freeman Publication* in Philadelphia. During these years, the occupants of the home were his mother, his sister Elizabeth, and his aunt Mercy, except when his frequent illnesses and the political events of the area called him home.

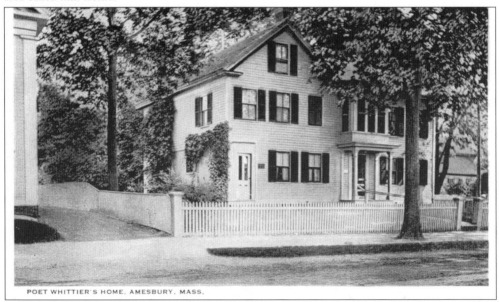

POET WHITTIER'S HOME, AMESBURY, MASS.

Whittier enlarged the house, raising up the original building at the left and adding another story, before adding the section to the right. The house is an amazing discovery for literature fans as one of the most authentic and engaging author homes ever visited. It remains unchanged since Whittier's death in 1892.

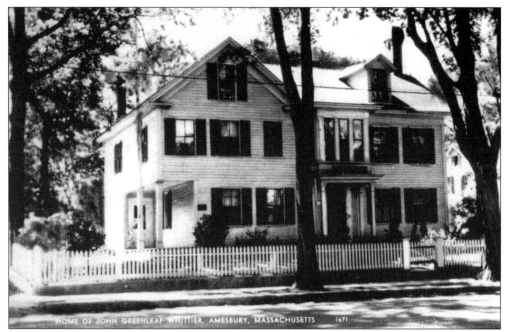

A somber Victorian sense pervades the house. Whittier was a 59-year-old bachelor when he became famous for the popular poem "Snow-Bound," which was originally intended as a publisher-assigned short poem. Whittier's presence is everywhere in the house. Many of the pictures remain just where he hung them. Rumor is that Whittier had portholes installed in doors so that his pet bird could flutter in and out of rooms.

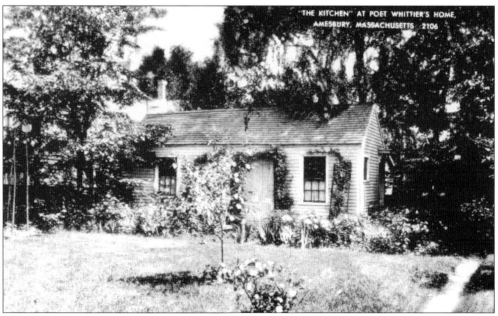

Shown here is the back kitchen of the Whittier house, containing the original hearth. The previous kitchen was removed and placed at the back of the yard when the Whittier museum was opened soon after the turn of the century. Today, the garden house is used for occasional functions.

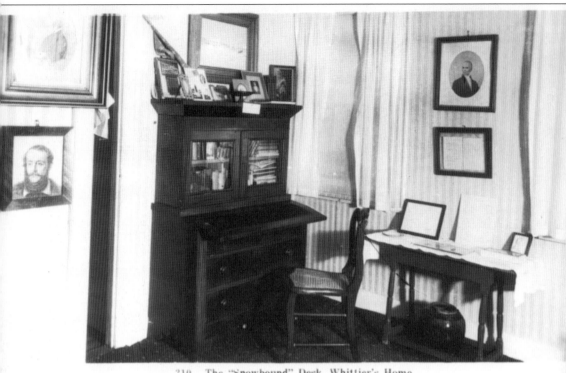

310. The "Snowbound" Desk, Whittier's Home,
Amesbury, Mass.

"Snow-Bound" was originally intended as a short poem, assigned to Whittier by James T. Fields, then the publisher of *Our Young Folks*. It is the story of the poet's boyhood at the homestead in Haverhill and is written as a Christmas poem. It ended up filling a small volume. In a drawer of the desk shown here is a book of signatures presented to Whittier on his 80th birthday by the Essex Club. Every member of the U.S. Senate, the House of Representatives, the Supreme Court, and many other distinguished citizens signed it.

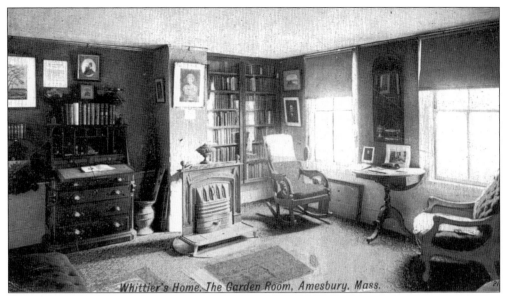

Whittier's Home. The Garden Room, Amesbury. Mass.

Most of Whittier's best-known poems and prose, such as his classic "Snow-Bound," were written in what is known as the "garden room" of the house he lived in at 86 Friend Street. During restorations in 1903, a stack of letters was found within the walls bearing the date of 1847—when renovations were initially made to the house. The money for the 1847 improvements came from Lewis Tappan of New York, who is considered the financier of the Anti-Slavery Society, as salary for Whittier's unpaid editorial work.

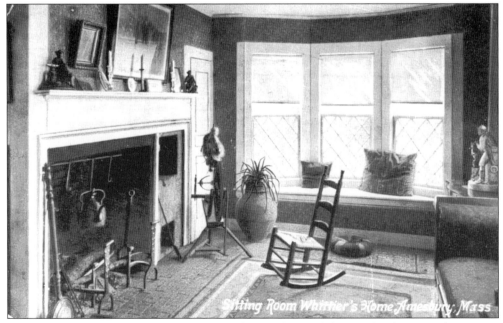

Sitting Room Whittier's Home Amesbury, Mass

Whittier's sitting room has been kept exactly as Whittier left it, right down to the carpets, wallpaper, and knickknack details. There is a musty scent of the past, and it is easy to imagine the poet working here at his desk near the stove with the humidifier, which was constantly operating because Whittier disliked the cold.

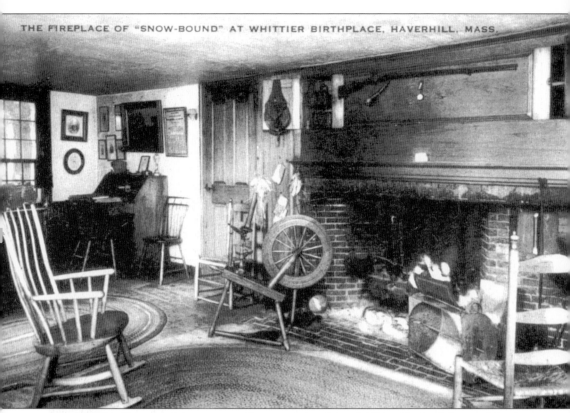

The Whittier Homestead is an outstanding example of the old New England farm and has been operated as such, without interruption, since the beginning. Its charm lies in the simple and homey atmosphere that has surrounded it since Colonial days. The house itself, located on its original site, is substantially the same as when the poet lived here from 1807 until 1836 and is the setting of his most famous and beloved poem, "Snow-Bound."

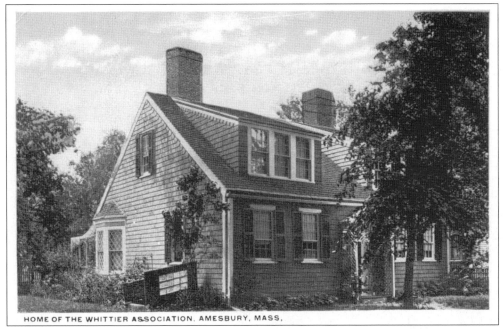

HOME OF THE WHITTIER ASSOCIATION, AMESBURY, MASS,

The house has been owned and maintained by the Whittier Home Association since 1918 and serves as a memorial to the poet and antislavery champion who made exceptional contributions to the life and literature of this country. This home at 7 Pickard Street is now a private residence.

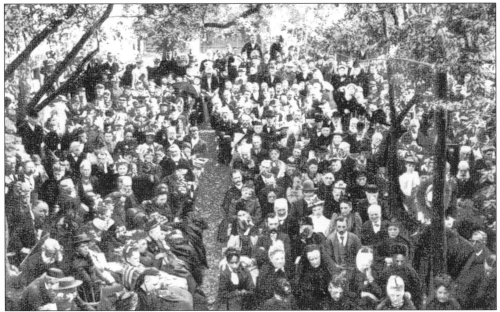

This scene shows the crowd of mourners in the backyard of this house at the poet's funeral in 1892. On the right in the second row is Portsmouth-born poet Celia Thaxter. Thaxter met Whittier when he brought his sister Eliza to Smuttynose Island for health reasons. Whittier and Thaxter were great supporters of the each other's work, and Whittier visited the Isles of Shoals often, crediting Celia as the inspiration for some of his seacoast works.

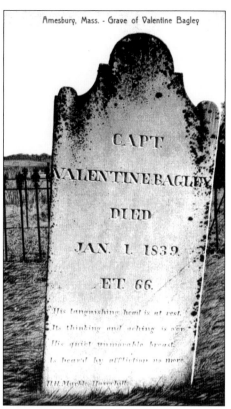

Amesbury, Mass. - Grave of Valentine Bagley

CAPT
VALENTINE BAGLEY
DIED
JAN. 1. 1839.
ÆT 66.

His languishing head is at rest.
Its thinking and aching is o'er
His quiet immovable breast
Is heaved by affliction no more.

H.H.Markle. Haverhill.

Capt. Valentine Bagley was born on January 1, 1773, in Newbury and died on January 19, 1839, in Amesbury. He lived in Amesbury and was the sea captain and subject of Whittier's poem entitled "The Captain's Well" in 1796. He was a charter member of the Warren Lodge of Free Masons in Amesbury in 1822 and served as its first treasurer. His grave lies in the Union Cemetery in Amesbury about 300 yards east of Whittier's family grave plot. His headstone is barely legible today due to weather erosion.

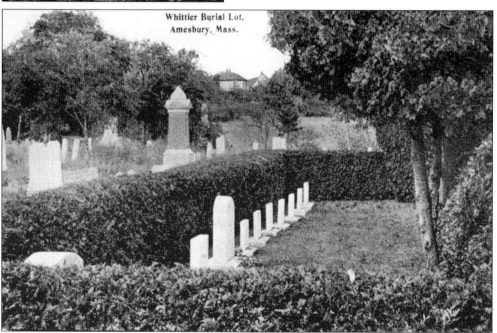

Whittier Burial Lot,
Amesbury, Mass.

John Greenleaf Whittier's grave is in a family lot in the Society of Friends section of the Union Cemetery in Amesbury. Other members of the household, as commemorated in the poem "Snow-Bound," are also buried there.

Six

ARCHITECTURE

OF WORSHIP

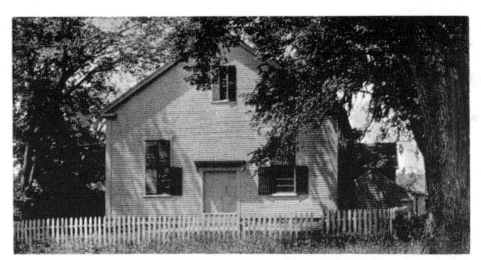

Quaker Meeting House, Amesbury, Mass. Built in 1851, and Whittier was Chairman of the Building Committee.

The year 1701 marks the earliest records of the Society of Friends, which was held at private homes until a meetinghouse was built. The original meetinghouse was 26 feet square, and the Friends orders from Hampton, Salisbury, and Amesbury all gathered in that little house. In 1850, the Society of Friends purchased the lot shown here from Eliphalet Barnard on Friend Street and built the present house.

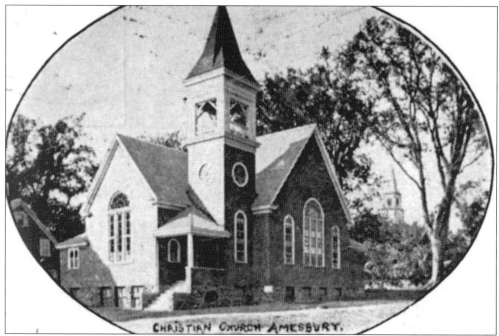

The Christian Church, which was also known as the Grace Baptist Church, is shown here. This meetinghouse was built in 1827 and enlarged in 1842. Major repairs were made 30 years later, and the interior was rearranged. In 1902, the cornerstone of the present church was laid, and the church was dedicated the next year as the Grace Baptist Church. One of the original sawpits servicing the boatbuilders of Point Shore was on this site. It is now privately owned. In the background, you can see the steeple of an earlier Baptist church located off Rocky Hill Road.

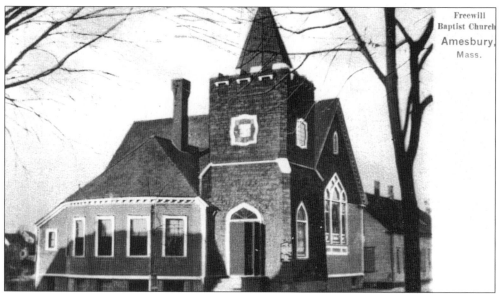

The Free Will Baptist Church was erected during 1851 and was dedicated in October of that year. In 1891, the bell-shaped roof tower and other radical architectural changes were made. The church is now privately owned and is located on Spring Street.

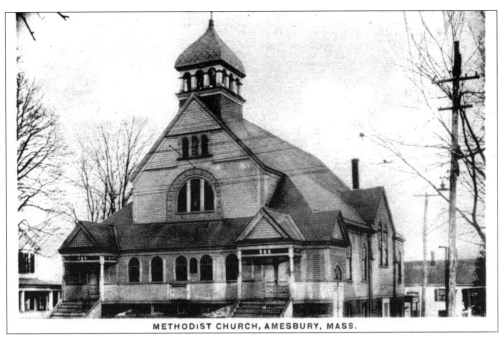

METHODIST CHURCH, AMESBURY, MASS.

The First United Methodist Church, located in Huntington Square on Main Street, was built in 1886 and looks virtually untouched from its dedication date.

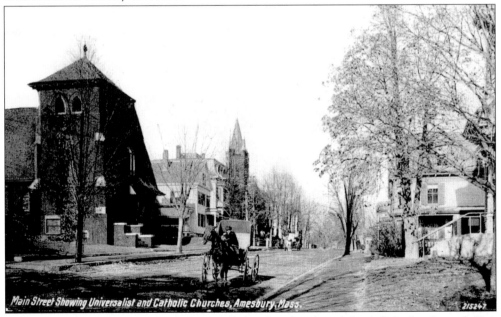

Main Street Showing Universalist and Catholic Churches, Amesbury, Mass.

Ascending Main Street from Patten's Hollow, the church on the left is the Seventh-Day Adventist Church, which was formerly the Universalist church. The brick church was built in 1904 opposite the Jacob Huntington home on Main Street. The first services were held in 1905 and continued through 1941. In 1945, the Universalist church was put on the real-estate market, and papers were quickly passed to the Seventh-Day Adventist Church. Between May and the consecration service on July 12, 1945, parishioners worked eagerly repairing, renovating, and redecorating the church.

In October 1836, construction started on the First Baptist Church of Salisbury and Amesbury. Upon its completion, the church was considered to be one of the "most beautiful specimens of early American architecture." In size, finish, and taste, it reflected honor upon the society, and its entire expense was met by the generosity of the people. In 1849, the meetinghouse was enlarged. The building was actually cut in half, and a section was inserted in the middle, which provided 24 more pews. In 1850, the roof was shingled in slate.

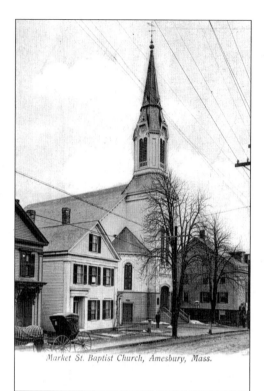

Market St. Baptist Church, Amesbury, Mass.

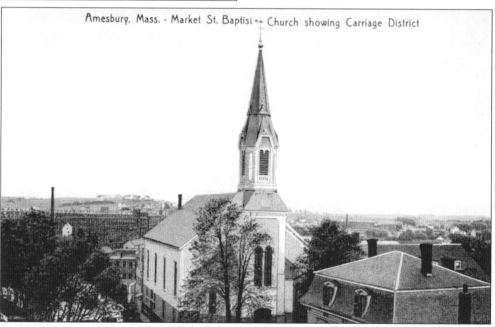

Amesbury, Mass. - Market St. Baptist Church showing Carriage District

In 1872, construction began on a new meetinghouse, which was completed that year for a cost of $35,000. In 1889, the name was changed from the Salisbury and Amesbury Baptist Church to the Market Street Baptist Church. The year 1894 saw some major improvements, such as the organ being moved from the rear of the church to the front behind the pulpit. The church bell was purchased in 1910 but, for undocumented reasons, was not hung until 1940.

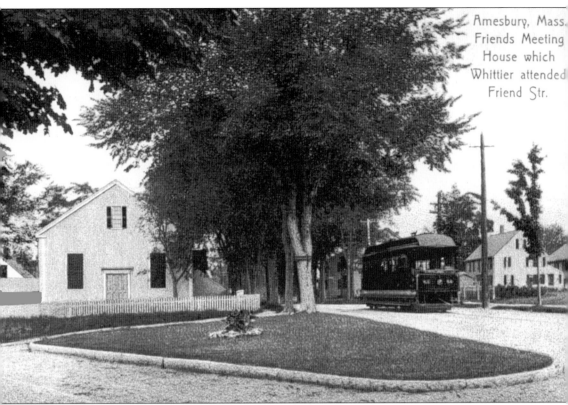

The Friends Meetinghouse, which serves the Society of Friends (Quakers), was built in 1851 based on plans drawn by John Greenleaf Whittier, who was chairman of the building committee. By design, the structure is plain and comfortable but not at all ornate. Its interior has not been changed since it was first built. The original meetinghouse stood where Sacred Heart Church, Amesbury's French Roman Catholic church, now stands.

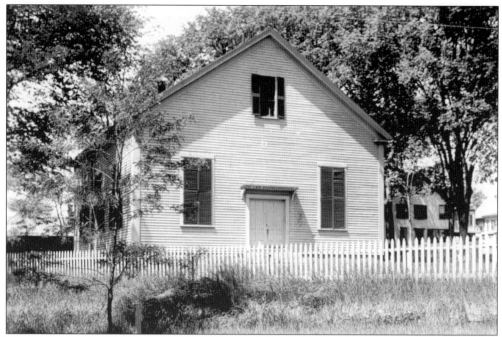

Whittier was a regular attendant at First and Fifth Day Meetings and described his penchant for Quaker worships in his poem "The Meeting." The location of the meetinghouse adds substantially to its historic and cultural value. On a lane lined with sugar maples, it perches on a small hill immediately overlooking the town park, which retains the rustic flavor of the 19th century.

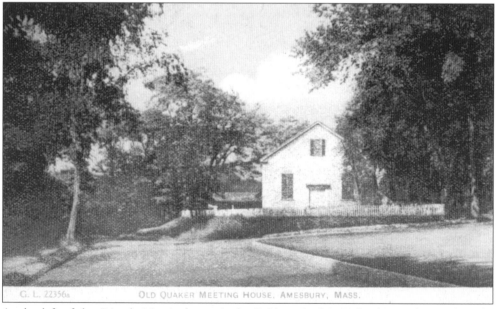

G. L. 22356a OLD QUAKER MEETING HOUSE, AMESBURY, MASS.

At the left of the Friends Meetinghouse is the "old road of 1641." This road started at the Merrimac River near the Amesbury Ferry and followed a Native American trail along the eastern side of what is now called Swett's Hill, through Sandy Hollow to the western slope of Whittier Hill, and then to the New Hampshire line. The section of Highland Avenue between Haverhill Road and Sparhawk Street, and including Greenleaf Street, are all that remains of this early road.

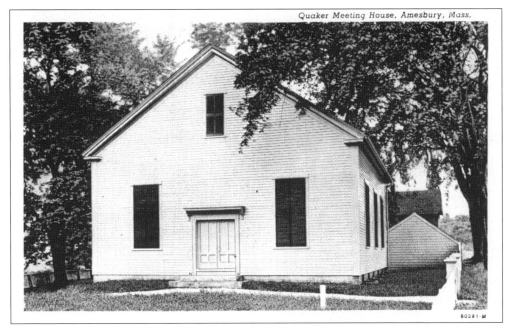

There is strong circumstantial evidence that the meetinghouse served as a stop for escaping slaves on the Underground Railroad. In 1991, a secret chamber was found under the floorboards during a basement excavation to build a space for the Head Start program (a child development program).

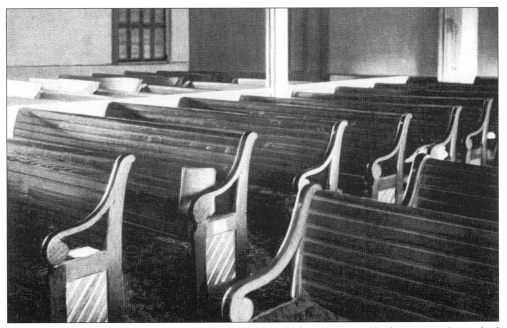

Visitors to the meetinghouse always seek out Whittier's favorite seat, which is currently marked by a small silver plate. The small plate is shown below the arm and alongside the seat, and a book is propped up against the back of the pew.

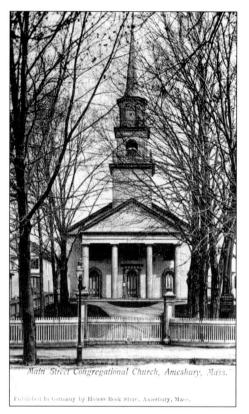

Main Street Congregational Church, Amesbury, Mass.

Founded in 1828, the meetinghouse of the Liberal Congregational Church became the Congregational Society of Amesbury and Salisbury Mills Village when the Liberal Congregational Church realized that two Congregational churches were unnecessary and sold their meetinghouse. In 1840, the Greek Revival porch and new spire were added, and the walls were frescoed by artist Samuel Rowell. In 1889, a parsonage was built at the corner of Sparhawk Street and is now the offices of attorney Charles E. Schissel.

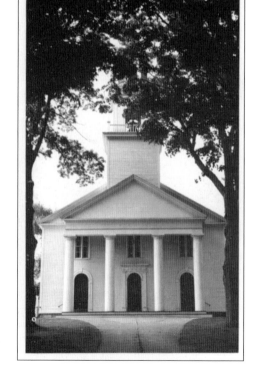

Main St. Congregational Church, Amesbury, Mass.

This church is a collection of several different architectural styles. The main body of the church was built by the Unitarian church and is a Colonial meetinghouse design, built *c.* 1829.

The St. James Episcopal Church was formed in 1833 in a building used as the Calvin Baptist Society vestry on Market Street, where services were held until 1836. In that year, the vestry was bought by the Episcopal parish and moved to the Main Street location. It was moved again in 1845 to Friend Street, where it became a blacksmith shop.

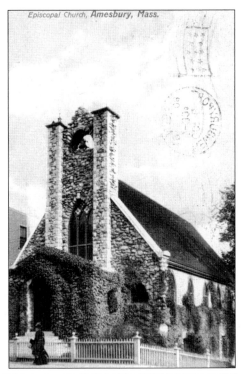

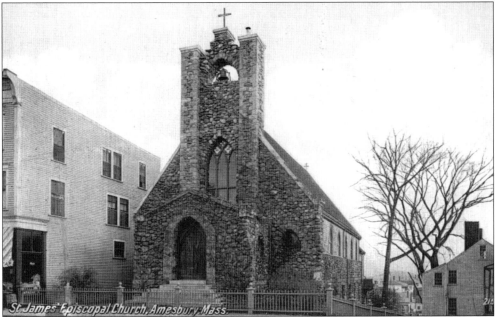

In 1845, a new St. James Episcopal Church was erected on the former site, and its present location, for $5,415.79. Supposedly, a stone from King George III's chapel exists in the foundation, although it has never been identified. The original plans for the church were drawn up in Italy. In 1899, the opera house fire destroyed this church, and the fifth and current structure was built soon afterwards. The cornerstone for the current church was laid on September 26, 1899, and completed in 1900 for the amount of $9,500.

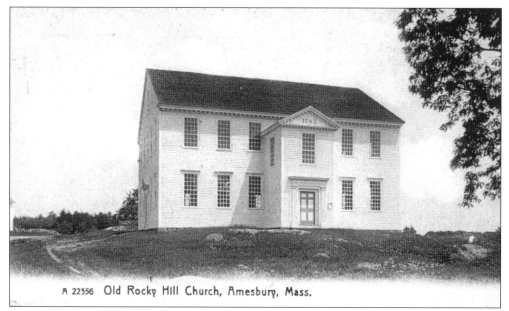

A 22356 Old Rocky Hill Church, Amesbury, Mass.

The Rocky Hill Meetinghouse was built *c.* 1785 to serve the west parish of Salisbury. This Massachusetts historic landmark is the least altered of any 18th-century country meetinghouse in Massachusetts. Rocky Hill was so named because melting glaciers left their most abundant deposit of boulders there. In 1789, parishioners gathered here to honor the visit of the first president of the United States, George Washington.

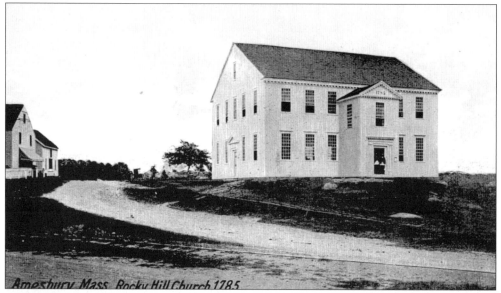

Amesbury Mass. Rocky Hill Church 1785

The Rocky Hill Meetinghouse was actually located in Salisbury until 1886. The present structure is a replacement of the original building, which was built *c.* 1640 close to what is now Salisbury Square. A new site was selected, construction commenced in the summer of 1714, and the church was completed two years later. People from Amesbury, Salisbury Plains, South Hampton, Seabrook, and Point Shore would attend, making the church quite centrally located. The parsonage—seen at the left in the photograph—was moved behind the meetinghouse in 1966, due to being in the path of construction of Route 495.

Elder Morton, born in 1804, was a pastor at the Rocky Hill Meetinghouse in the mid-1800s. The caption reads, "The winds blew and the storms beat upon that house, And it fell not because it was founded upon a rock."

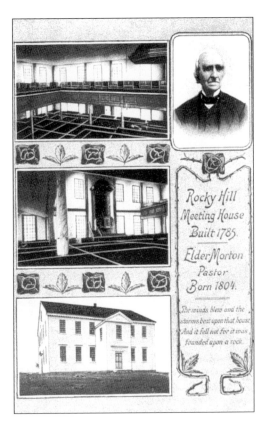

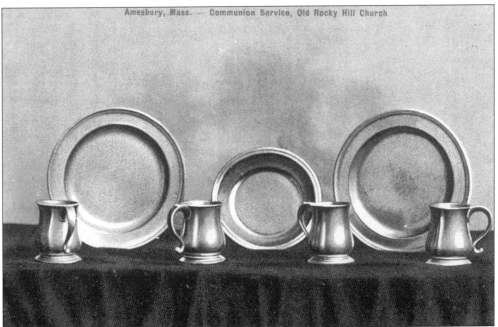

Shown here is a pewter communion service that is used during mass services at the Rocky Hill Meetinghouse. It still is on display as shown in this scene.

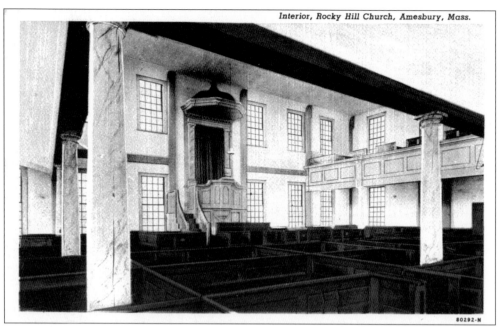

The Rocky Hill Meetinghouse interior has remained virtually unchanged since construction in 1785 and features the original high pulpit, pentagonal sounding board, box pews, deacon's desk, and gallery connecting three sides. The Rocky Hill Meetinghouse survives as an outstanding example of early-American church architecture.

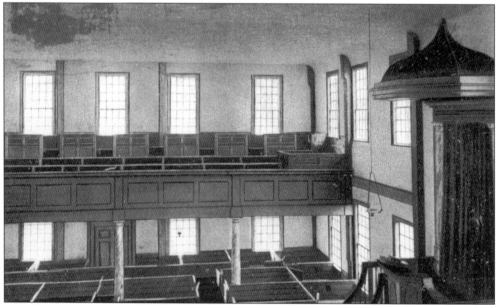

The Rocky Hill Meetinghouse, located at the top of Rocky Hill Road on Elm Street, was built in 1785 and was so named due to the abundance of boulders in the surrounding area left by melting glaciers. The Society for the Preservation of New England Antiquities now owns and cares for this historic building. It is thought that Timothy Palmer and Richard Spofford constructed the Rocky Hill Meetinghouse. All ministers were Harvard graduates until 1835, when a Dartmouth man filled the pulpit.

Sacred Heart parish was officially established on the Feast of St. Joseph, March 19, 1903. In June of that year, the parish purchased the Free Will Baptist Church property for $6,500—a debt that was paid in full within one year from 10¢ collected from each working parishioner every week. This property on Friend Street was originally the meetinghouse of the Society of Friends (Quakers) prior to use by the Baptists.

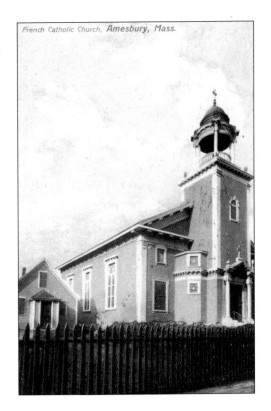

French Catholic Church, Amesbury, Mass.

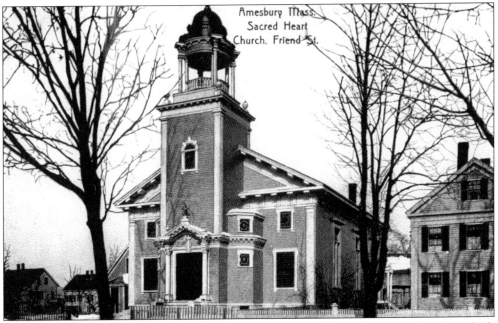

Amesbury Mass. Sacred Heart Church. Friend St.

Shown here, the original church served as Sacred Heart from 1903 until the new church was built between February and December 1928. The old church was moved to the rear of the schoolyard and had served as a hall for the Catholic Youth Organization for many years. Several years ago, the old church was leveled.

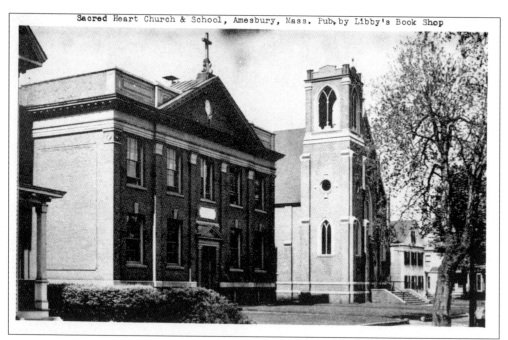

Sacred Heart French Catholic school and church, shown here, are located on Friend Street. The two buildings have essentially the exact same outward appearance that they did when they were built.

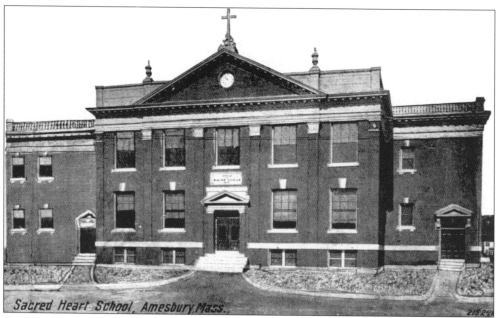

Construction on Sacred Heart School began in April 1910 for $25,000, and the school was dedicated on January 31, 1911. In 1923, tuition was declared free—to be funded by a special monthly church collection—and by the end of 1923, the school was serving 800 students. The school closed in 1976 and is used today for religious education and youth activities. The building is still considered one of the parish's greatest assets.

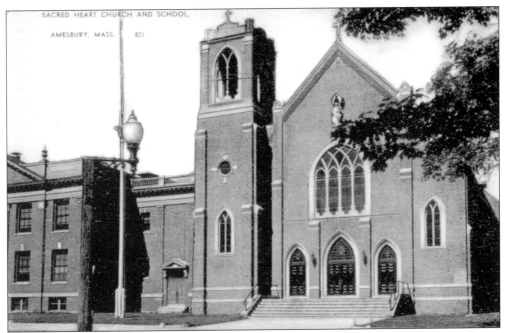

SACRED HEART CHURCH AND SCHOOL, AMESBURY, MASS. 821

Over the years, the Sacred Heart parish established a highly successful parochial school, purchased a rectory, and built the present church, as shown here.

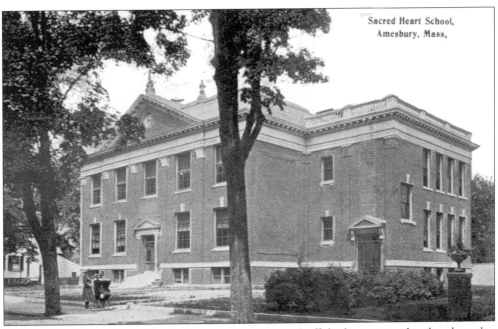

Sacred Heart School, Amesbury, Mass,

In 1910, the Sisters of Sacred Heart's convent was moved off the lot next to the church so that a new school could be built there. This was accomplished at a cost of $25,000, and Sacred Heart French Catholic School was opened, with classrooms on the first floor and a parish hall on the second. Quickly, enrollment increased, so it was necessary to open six more classrooms on the second floor.

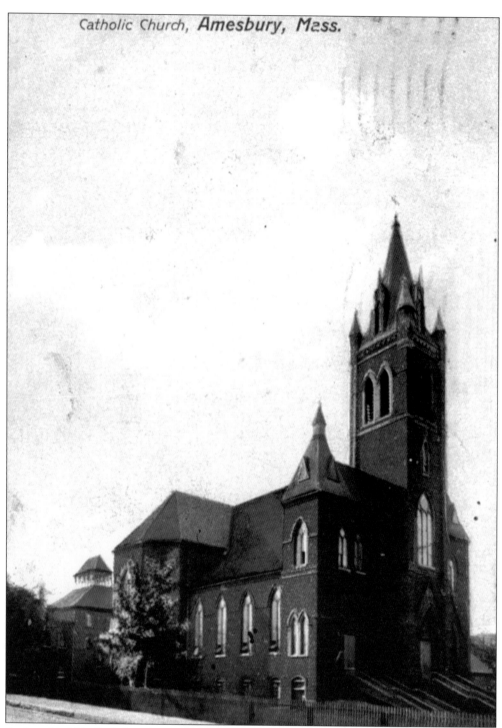

Catholic Church, **Amesbury, Mass.**

St. Joseph's Irish Catholic Church, at the time of construction, was considered one of the finest church properties in the archdiocese of Boston. The large brick gothic-style building houses both an upper and lower church (each with its own pipe organ) and began construction on the Eve of the Feast of the Pentecost on May 30, 1872.

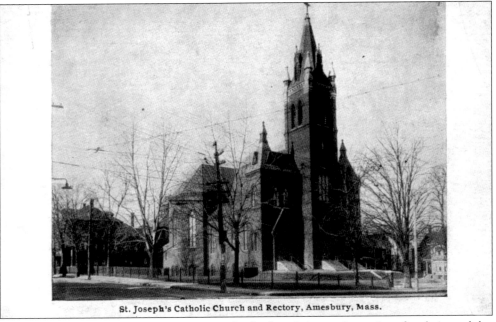

St. Joseph's Catholic Church and Rectory, Amesbury, Mass.

Parishioners started digging and laying stones for the foundation each evening after their workday ended, under portable lights held by women of the parish. The church was dedicated on May 7, 1876.

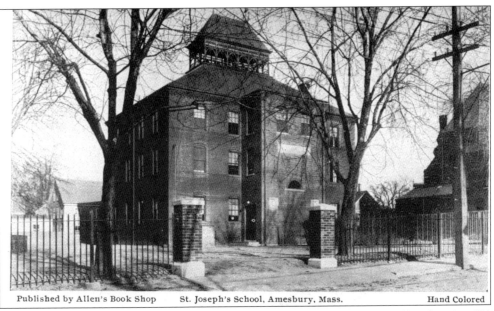

Published by Allen's Book Shop St. Joseph's School, Amesbury, Mass. Hand Colored

Construction of St. Joseph's school started in June 1884. The school was capable of seating 500 pupils and held a 600-person auditorium on the third floor that was capable of being segmented into four additional classrooms if needed. Its basement held a boiler that would provide heat for both the school and the church, which was about 100 feet away. A belfry was added in October 1885 with a 900-pound bell that was first rung on November 17, 1885.

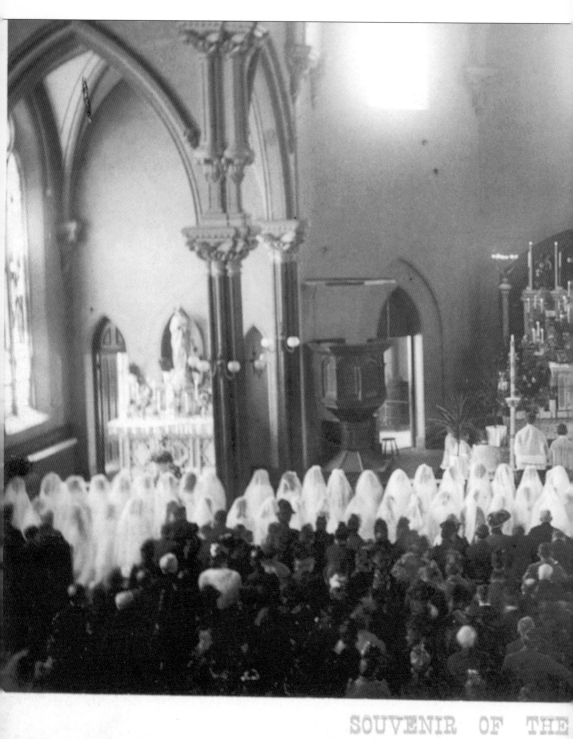

An 1891 photograph of St. Joseph's "mission"—a 25-year silver jubilee of St. Joseph's parish—

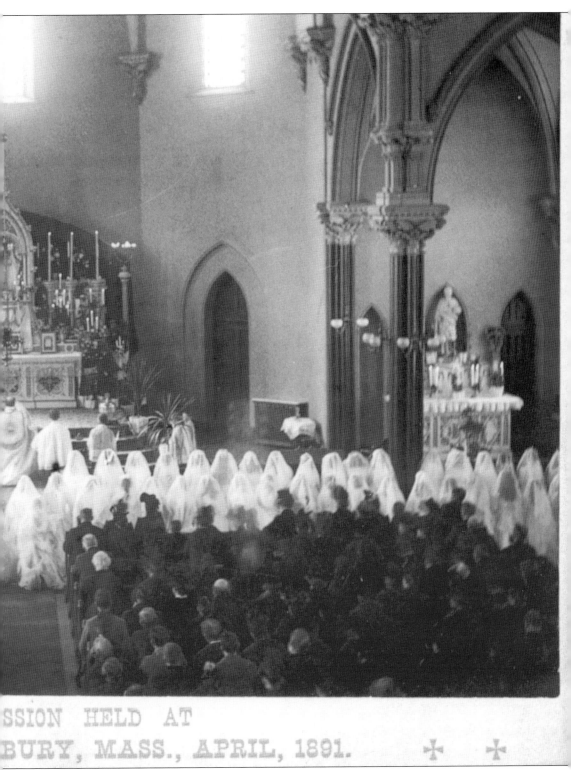

shows the original wooden altar and raised wooden pulpit at the left.

St. Joseph's stands 150 feet long by 100 feet wide, and the tallest point—a gold cross at the top of the center spire—reaches 250 feet above sea level. The three spires have changed significantly over the years due to repairs and renovations. A new center spire and a 3,000-pound bell were erected in April 1904 and were renovated again from 1941 through 1943.

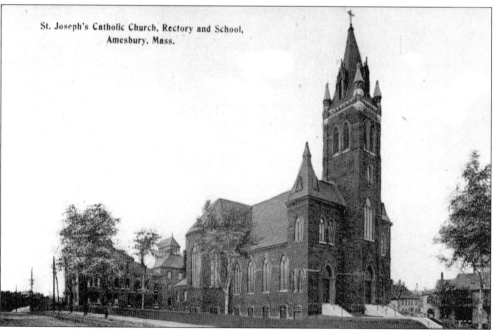

St. Joseph's Catholic Church, Rectory and School, Amesbury, Mass.

Major renovations to the church structure and the upper and lower church interiors were started in 1964 and completed in 1966 for the parish's 100th anniversary. In 1995, the roof was replaced and the upper pipe organ again restored. In 1997 and 1998, the upper church was renovated in time to reopen for Palm Sunday 1998. It continues to be one of the most beautiful churches in New England.

Seven
ALONG MAIN STREET

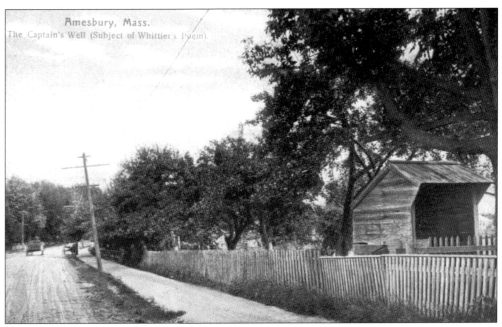

Shown here is the earliest facade of the Captain's Well, which has also been known as the Bagley Well in tribute to Capt. Valentine Bagley, who dug the well. The well is located on Main Street at the right front of the Amesbury Middle School lot. As this photograph shows, Main Street near Bartlett's Corner in the late 1800s was quite overgrown and undeveloped.

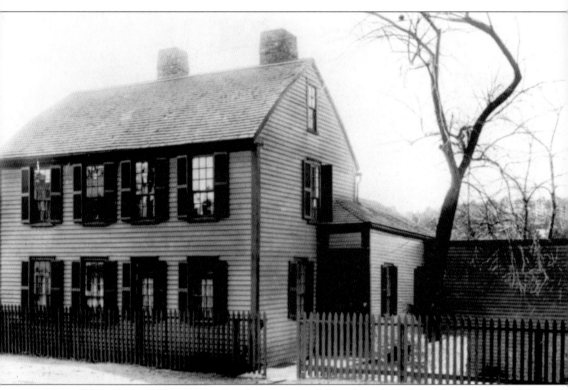

Mary Baker Eddy (1821–1910), the discoverer and founder of Christian Science, is widely recognized as one of the most remarkable religious figures of modern times, as well as one of Amesbury's most intriguing figures. This small Colonial house at 277 Main Street was formerly the home of squire Lowell Bagley, a citizen of Amesbury who held nearly every public office in the town. His daughter Sarah invited Mary Baker Eddy (Mary Glover at that time) into their home far a short visit that lasted two years.

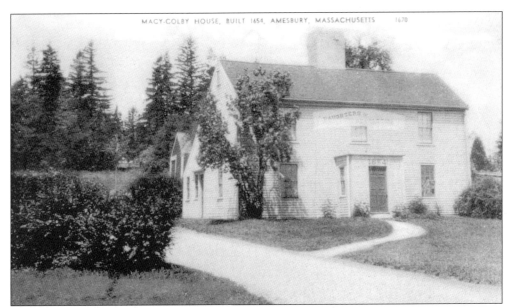

This house is considered one of the best-preserved examples of early Americana in existence. It was built *c.* 1652 and was the home of Thomas Macy until he moved to Nantucket Island in 1659 and it was sold to Anthony Colby. Anthony Colby, who came from England in 1630, was number 93 on the list of church members at Boston. He died in February 1661 in Amesbury.

The Macy-Colby House, Built 1654, Amesbury, Mass.

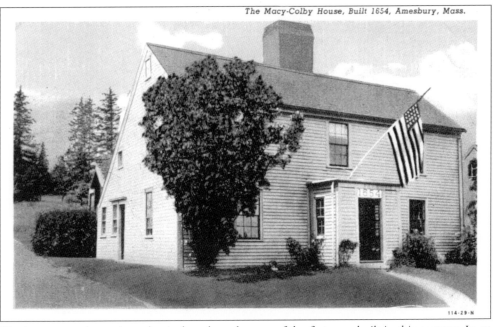

The house contains a piano that is thought to be one of the first ever built in this country. In an upstairs bedroom is a little cradle where Susannah Martin ("Amesbury's witch") once lay as a child. Nine generations of Colbys lived in the house. There is an eight-foot fireplace in the kitchen that has not only the usual cooking accouterments but also a small forge and vise to fashion nails and tacks. At the time, it was common for a kitchen to have an instrument for making nails. The home's conveniences include a tub cut from a single Hornbeam tree trunk.

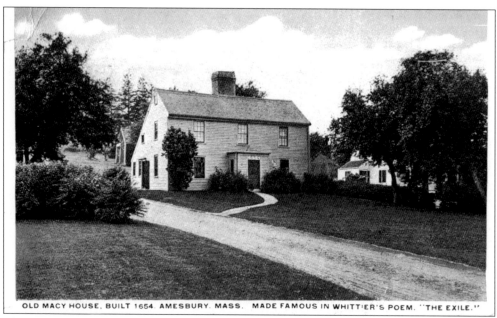

OLD MACY HOUSE, BUILT 1654. AMESBURY. MASS. MADE FAMOUS IN WHITTIER'S POEM. "THE EXILE."

The original Macy-Colby House consisted of just the two front rooms on the ground floor and a loft above. Later, a keeping room was added at the rear and two rooms on a second floor. A kitchen was eventually added behind the keeping room. To this day, no running water, electricity, or modern heating has been added. The last Colby moved across the street in 1958. The house and property currently belongs to the Bartlett Cemetery Association and is cared for by the local Josiah Bartlett chapter of the Daughters of the American Revolution.

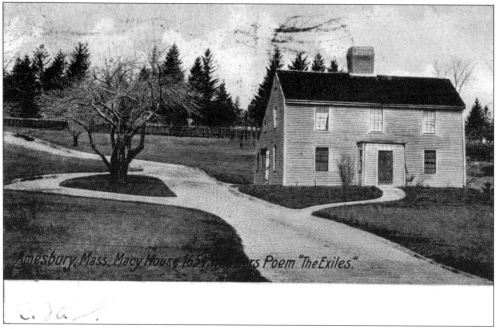

This is a pastel drawing of the Macy-Colby House by noted Amesbury artist, photographer, historian, and lecturer Willard E. Flanders. Flanders was a frequent contributor to local newspapers with items of historic interest.

92

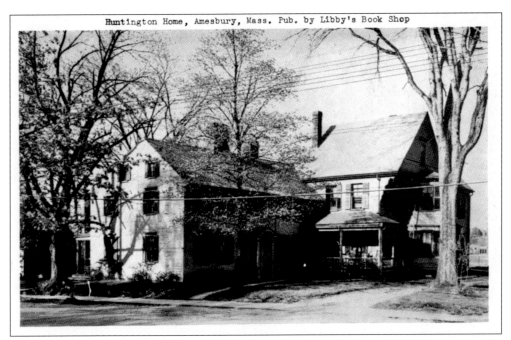

Located on Main Street between Bartlett's Corner and the Captain's Well Monument, the Huntington House stands as a sprawling memory of the past. Valentine Bagley, who legend suggests dug the Captain's Well, was the tavern keeper at this location until his death in 1839.

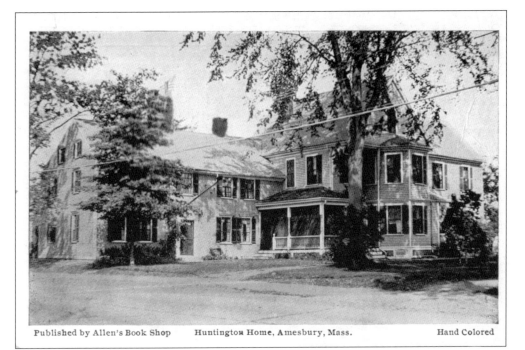

Upon Valentine Bagley's death in 1839, the tavern became the private residence of Daniel Huntington. The swinging tavern sign was left at the street end of the house, summoning the weary traveler that here he might find a home.

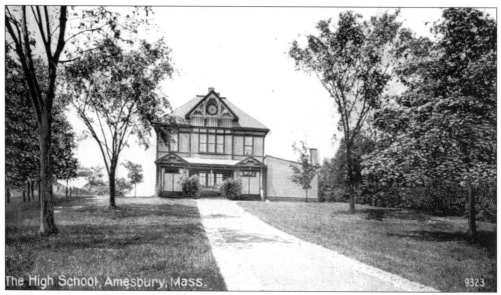

The High School, Amesbury, Mass. 9323

The Academy was first built in 1805, and during a public bonfire celebration, it was accidentally set and burned to the ground in 1870. In 1882, a high school was built on the same site and was expanded with an addition in 1896. In 1918, the seventh and eighth grades were moved into this building, and it was renamed the junior high school as the new Amesbury High School was being built across the street, on the site of the present Amesbury Middle School. In 1953, this junior high school was condemned, and the students were transferred to the high school building.

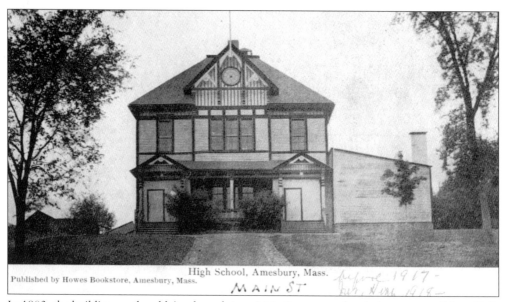

Published by Howes Bookstore, Amesbury, Mass.
High School, Amesbury, Mass.

In 1903, the building on the old Academy lot on Main Street was already in poor condition. Built on land leased for 99 years beginning in 1874, the property could only accommodate 150 students. An addition was made to the structure in 1906. The Academy property is now the William B. Justin Memorial Park. Justin died aboard the USS *Forrester* on July 29, 1967, in Vietnam—this memorial park was built in honor of those who served in Korea, World War II, and the Vietnam War.

94

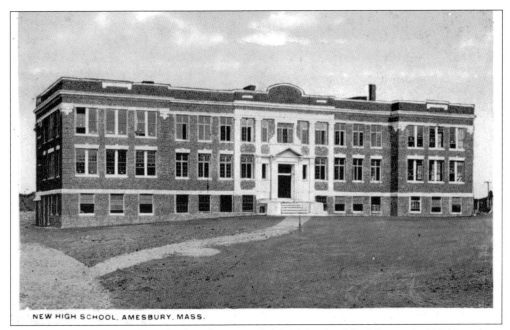

NEW HIGH SCHOOL, AMESBURY, MASS.

In October 1916, ground was broken for a new brick high school building to hold 500 students on Main Street (on the site of the current middle school). The school was ready for students after the Thanksgiving holiday of 1917, at a tuition rate of $60 per pupil.

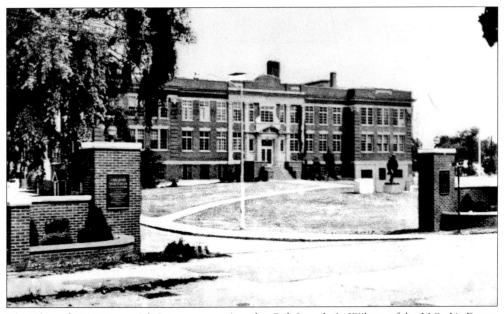

The Class of 1910 Memorial Gateway was given by Col. Joseph A. Wilson of the U.S. Air Force, who retired on July 16, 1961. Commemorative plaques on each pillar of the gateway were unveiled by drawing aside two 50-star flags that once flew in Washington, D.C. The high school gateway is now part of the front lawn of the Amesbury Middle School, its entrance closed with a wrought-iron fence, and serves as a monument to the old high school. The original dedication plaque indicating the location as the Amesbury High School is still displayed.

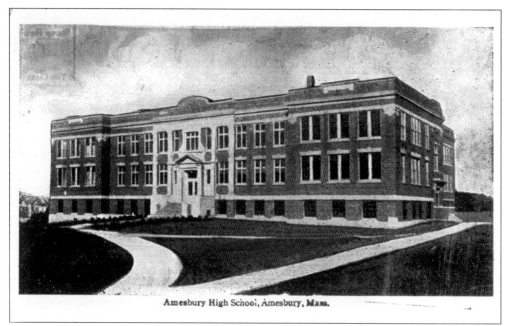

Amesbury High School, Amesbury, Mass.

On April 7, 1964, during second period, a raging fire broke out at the Amesbury High School on Main Street. In less than two minutes, 650 students all left their classes safely. By midafternoon, only the brick walls remained. The ruins were razed flush with the ground, and in June 1966, construction of the new middle school was begun. The new school opened on January 2, 1968.

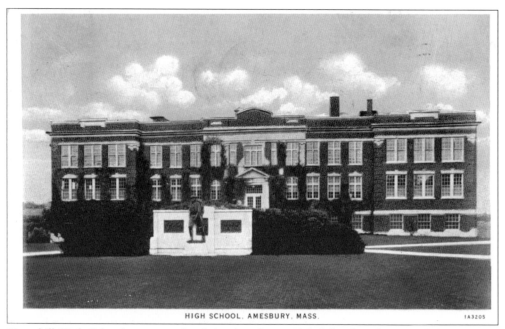

HIGH SCHOOL, AMESBURY, MASS. IA3205

Haverhill High School accommodated the Amesbury High School students until the new and current Amesbury High School opened during October 1968. The Amesbury Middle School is now on this site, and the World War I *Doughboy* statue (moved closer to the road during a middle school expansion project in 1997) still defends the front lawn.

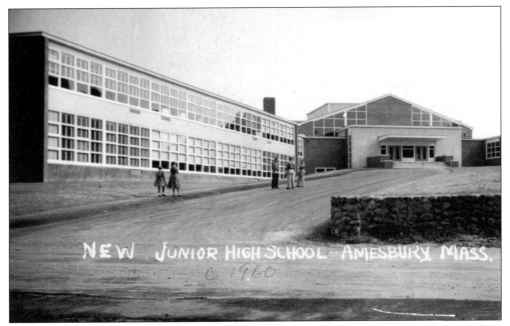

The middle school had been built behind the old high school. After the high school fire of 1964, the high school lot was leveled, and for a time, only the middle school remained. The new Amesbury Middle School shown here was dedicated on April 21, 1968, and was occupied on January 2, 1968.

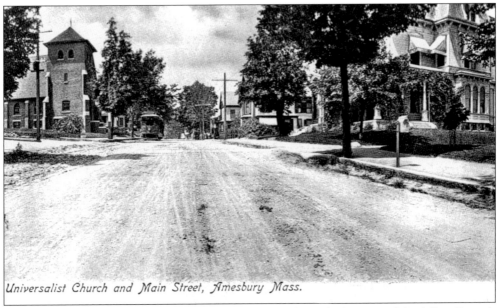

Universalist Church and Main Street, Amesbury Mass.

The view in this postcard faces north up Main Street from the bottom of the hill at Patten's Hollow. The church at the left is the Universalist church. In 1904, this brick church was built opposite the Jacob Huntington home on Main Street.

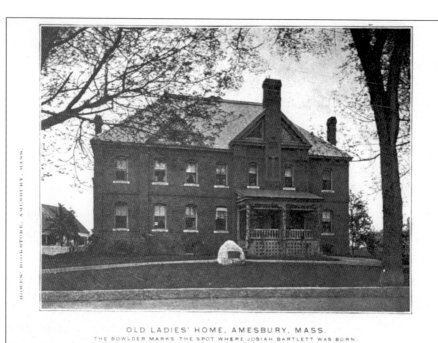

OLD LADIES' HOME, AMESBURY, MASS.
THE BOWLDER MARKS THE SPOT WHERE JOSIAH BARTLETT WAS BORN.

A boulder with bronze marker at 276 Main Street in Amesbury marks the site of the modest house in which Josiah Bartlett was born. The home was razed *c.* 1877 to make room for the Bartlett Home for Aged Women in 1878, only a few months after the great Carriage Hill Fire ravaged Amesbury. John Greenleaf Whittier left $10,000 in his will to the home.

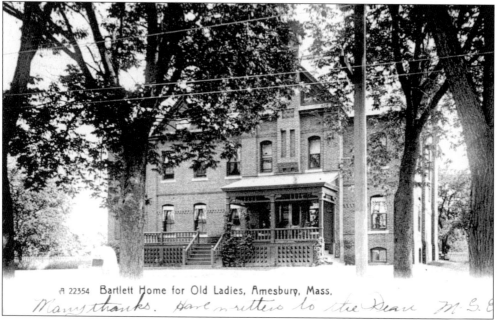

A 22354 Bartlett Home for Old Ladies, Amesbury, Mass.

In 1876, the Pickering estate was purchased for the purpose of erecting a suitable building for an old ladies home. Later, in 1878, a fair was held at the Merrimac Hat Company for the benefit of the home and raised $1,011.28. Similar events were held periodically, as needed, to continue to provide nursing home care and services.

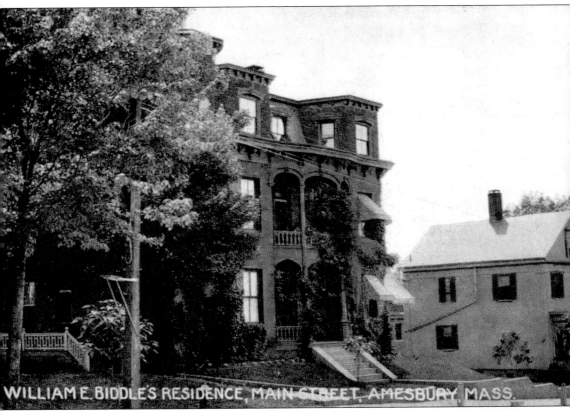

WILLIAM E. BIDDLE'S RESIDENCE, MAIN STREET, AMESBURY, MASS.

This was the 180 Main Street mansion of William Biddle of the Biddle and Smart Carriage Company in Amesbury. One of the largest producers of carriages in the world, they grew to occupy nine factory buildings by 1880. In 1915, Biddle and Smart was the largest builder of automobile bodies in the world. The Biddle house was an American Legion home for many years and, in 1977, became the entrance building of the Heritage Towers Apartments for the Elderly.

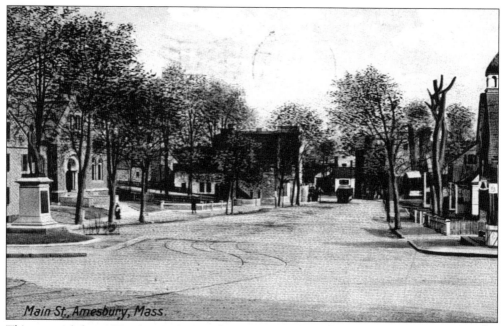

Main St., Amesbury, Mass.

This postcard shows Huntington Square, facing east. At the left is the Amesbury Public Library, and on the right is the Methodist church. Some of the trees from this particular view are still shading the visitors to town. This area is one of the many in Amesbury that received exceptional redevelopment work.

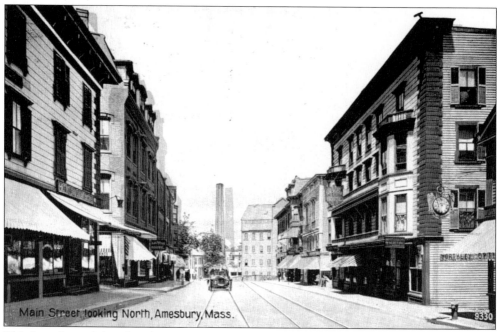

Main Street, looking North, Amesbury, Mass.

This is a view of Amesbury's Main Street, looking north toward Merchant's Row and taken *c.* 1920. Note the additional stories on the former electric company building in the background to the left.

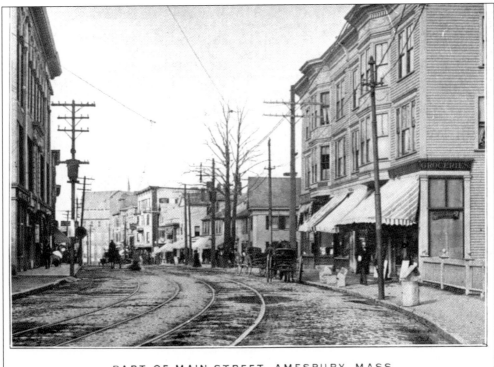

PART OF MAIN STREET, AMESBURY, MASS.

Until a fire in 2001 destroyed the block to the right of this 1905 photograph, the buildings in this section of downtown Amesbury were virtually unchanged. The two small houses in the center were replaced by the "New Post Office" in the late 1800s, and the electric trolley tracks were part of Amesbury's streets—though unused for years—well into the 1960s. Several horse-and-buggy drivers can be seen along the curbs, parked like cars are today.

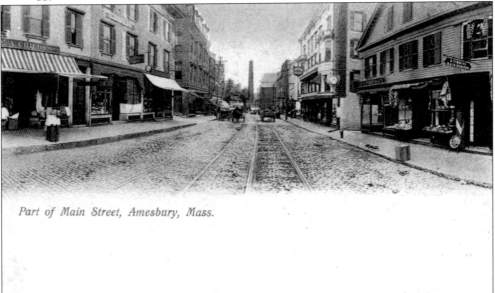

Part of Main Street, Amesbury, Mass.

A little farther toward Market Square, this view of Main Street looks east toward Merchant's Row.

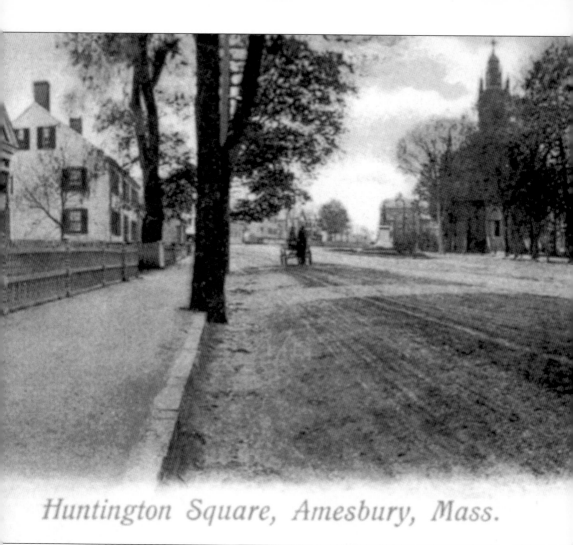

Huntington Square, Amesbury, Mass.

In this view of Huntington Square, at the right is the Amesbury Public Library, and in the center, poking out of the trees, is the rarely seen original steeple on St. Joseph's church. Richard Currier, one of Amesbury's first selectmen in the mid–1600s, had five sons. Three of the sons lived in the three houses shown at the left, all of which were built between 1780 and 1800 and still stand. In

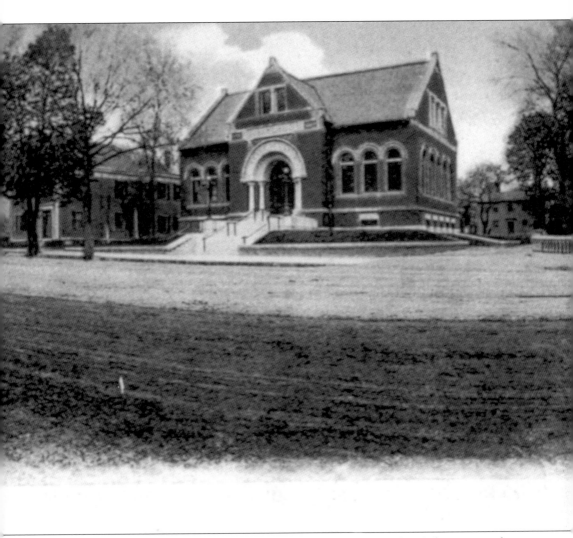

1762, at the foot of Currier Street and on a spur of the Powow River, Currier's great-grandson, also named Richard, established a shipyard, which carried on until *c.* 1830. Many of Amesbury's famous vessels, including *Polly,* were built at this shipyard.

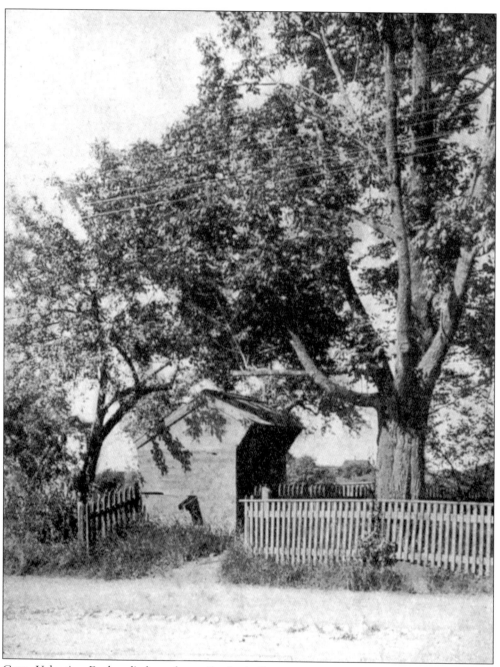

Capt. Valentine Bagley died nearby at Bartlett's Corner on January 19, 1839. John Greenleaf Whittier immortalized the seafarer's plight in 1890: "And if ever I reach my home again, / Where Earth has springs, and the sky has rain, / I will dig a well for the passers by, / And none shall suffer, from thirst as I. // Now the Lord be thanked, I am back again, / Where Earth has springs, and the skies have rain, / And the well I promised by Oman's Sea, / I am digging for Him, in Amesbury."

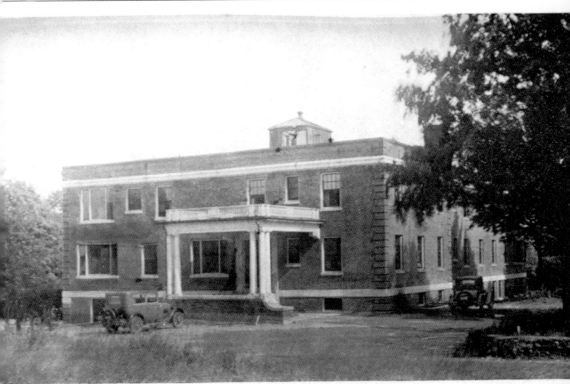

ublished by Allen's Book Shop Amesbury Hospital, Amesbury, Mass. Hand Colored

Ground was broken on August 19, 1926, and Amesbury Hospital opened to its first patients on December 18, 1927. In 1929, Amesbury's voters decided to take over the hospital for the amount of debt it had accrued. In 1965, a one-story addition was constructed on the south side of the hospital, and much remodeling was done to bring the hospital up to date. This new wing opened in 1966 and is now known as the Amesbury Health Center. Shown as it was originally constructed, this would be to the left side of the current entrance. The covered entrance, as shown, was removed and closed during the renovation project of 1966. The observation deck at the top of the building was also removed. The construction project was added to the right of this photograph. The street along the front of this photograph is the street known as Morrill Place.

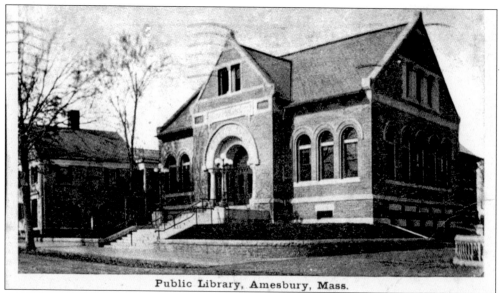

Public Library, Amesbury, Mass.

Joshua Aubin was closely connected with the Amesbury Flannel Manufacturing Company, which had maintained a small library for its employees. When the company was sold, Aubin took the 750 books to his home in Newburyport. Upon learning that Amesbury was attempting to set up a public library, he immediately offered the books.

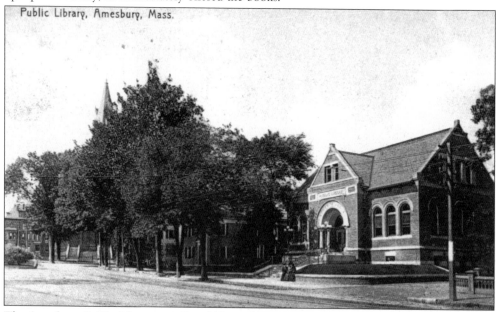

Public Library, Amesbury, Mass.

The Amesbury Public Library was founded in 1856 with 750 books donated by Joshua Aubin, a prominent businessman of the town. For 10 years, the library was kept in various rooms provided by the Salisbury Mills. For the next 40 years, the library was settled on the first floor of a building on School Street—now used as the St. Jean Baptiste Society club. The present library building, built on land donated by Dr. Nehemiah Ordway, has been a charming part of the town since 1902. Poet John Greenleaf Whittier is among those who served on the board of trustees through the years. The building was constructed in the Romanesque style, and the interior has not changed significantly through the decades.

106

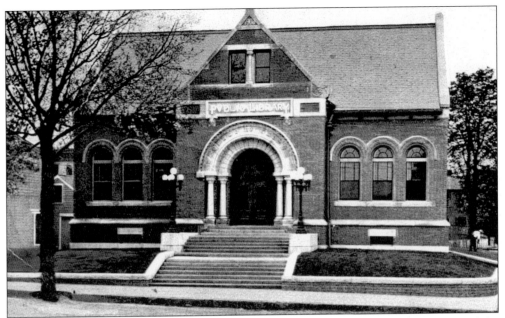

The Amesbury Public Library was founded in 1852 with 224 subscribers. The success of the library led to a town-funded public library in the late 1800s. In 1900, construction began on the current Romanesque-style building in order to expand the library's capabilities for a population that had swelled to about 9,000 people. Circulation was approximately 28,000 items in 1900. The next major change came in 1948, when the children's department took over the second floor in order to keep up with increasing demand for service. In the last 10 years, renovations to the basement were undertaken in order to provide more usable workspace.

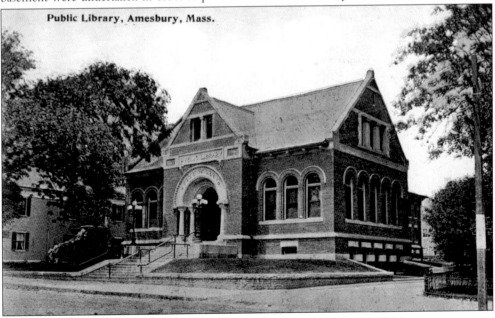

Currently, the 11,000-square-foot structure circulates approximately 118,000 items per year to a population of over 16,000 people. Studies are under way to plan for the expansion of the facility to meet the needs of future generations of Amesbury.

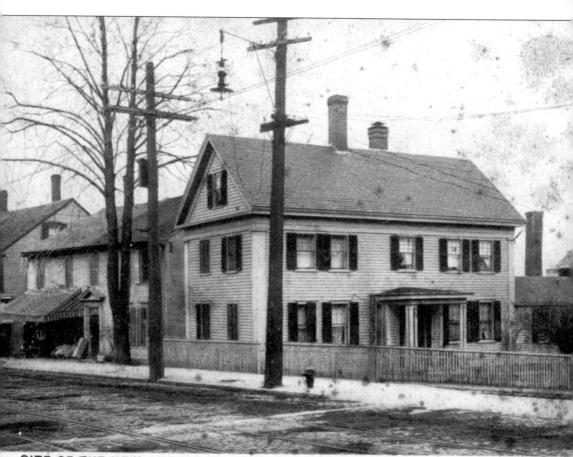

SITE OF THE NEW AMESBURY POST OFFICE BEFORE REMOVING THE BUILDINGS.

The two houses in this photograph were removed to provide the Main Street location for the new post office building in 1905.

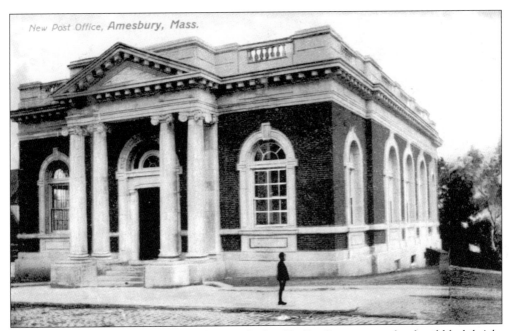

New Post Office, Amesbury, Mass.

In 1905, for $55,000, the new post office was built of Indian limestone and red and black bricks made from Amesbury's red clay by the Amesbury Brick Company. The Biddle and Smart Company contracted all of the exterior and interior woodwork. Two houses were removed to make way for the magnificent new building. In 1905, the annual salary of the postmen who carried and delivered the mail to the Point Shore area was $50.

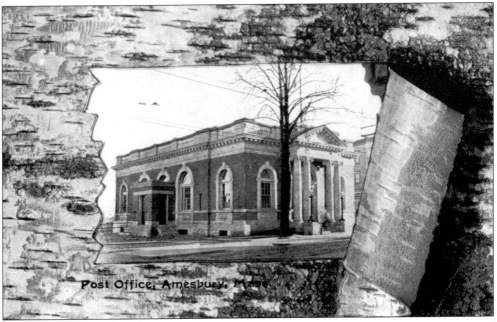

Post Office, Amesbury, Mass.

In the 1900s, this popular style of postcard shows a technique that gives the appearance of stripping the bark from a tree and seeing a panorama inside the tree. Today, the technique seems a misuse of image space.

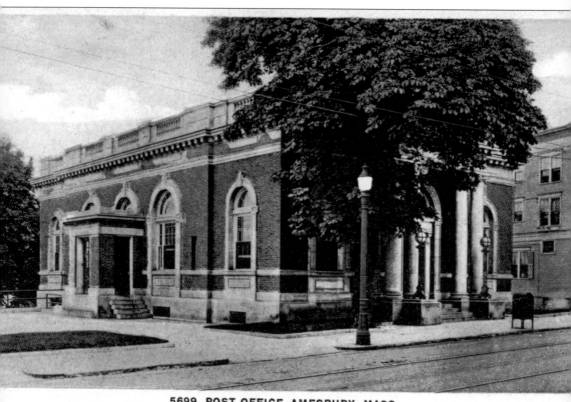

5699. POST OFFICE, AMESBURY, MASS.

In April 1975, the federal postal department bought land in Patten's Hollow. It was not until a routine postal inspection that it was discovered that the existing post office was dramatically overcrowded and there were sorting tables filling virtually every open space. The new post office was dedicated in 1977.

This is the Wilman Block, which is located on the site next to the area where the former Opera House stood before it burned to the ground. Over the years, many merchants have set up shop in these stores.

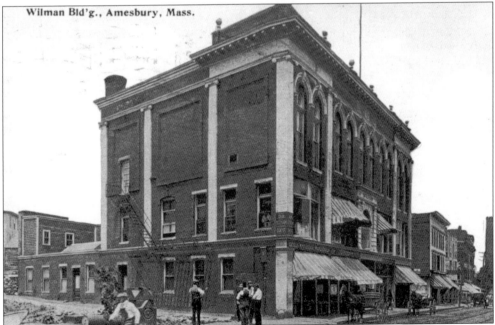

The Wilman Block accommodated the post office at one time, just before the Main Street Post Office was built and opened for business across the street. The building currently houses the Amesbury Offices of the Superintendent of Schools and Student Services.

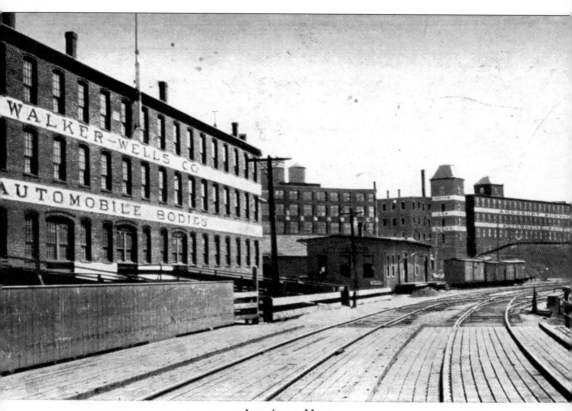

Amesbury, Mass.

The Walker-Wells Company built wooden automobile bodies from 1900 through 1910. Their automobile bodies were then hand-hammered or "bumped" from aluminum, until the first power hammer was invented in Amesbury, and bodies were created from stamped metal. In 1926, Walker-Wells employed 1,500 people and produced 9,000 bodies for 20 different auto companies. They closed operations in 1931 at the onset of the Great Depression.

Eight

MARKET SQUARE

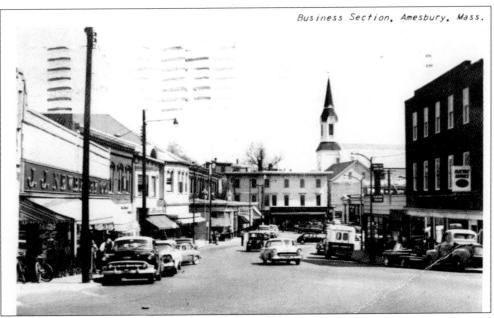

What town center could exist without its J.J. Newbury's discount store? This scene of Amesbury's business section, also known as Merchant's Row, shows Market Square as many lifelong residents know the area to look like in the fairly recent past. The most consistent image is that of the towering Market Square Baptist Church steeple keeping watch over the village.

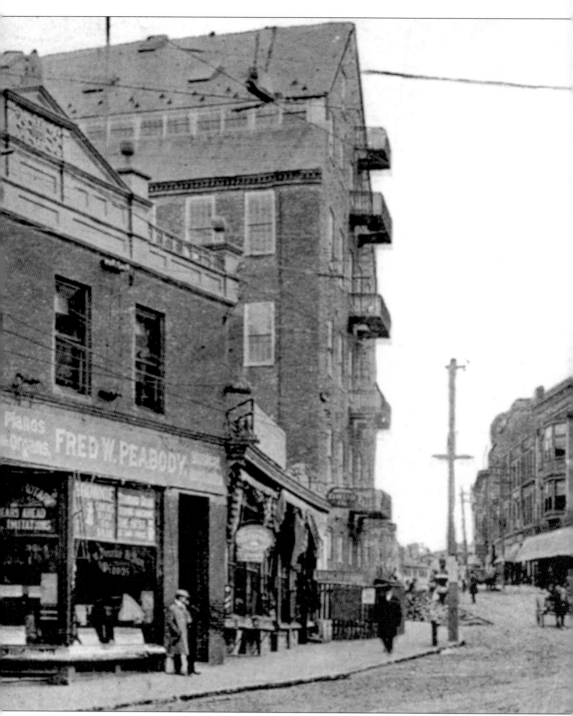

The tall building to the right of this photograph was the clock tower of the No. 8 Mill—the factory for the Hamilton Woolen Company, and later one of the Bailey Carriage Companies. Behind this block were buildings known as the counting rooms, which were the financial offices of the local textile mills. This is also the original 1829 location of the Provident Institute for Savings. Except for the smaller block at the center of this scene, all of these tall buildings and trees

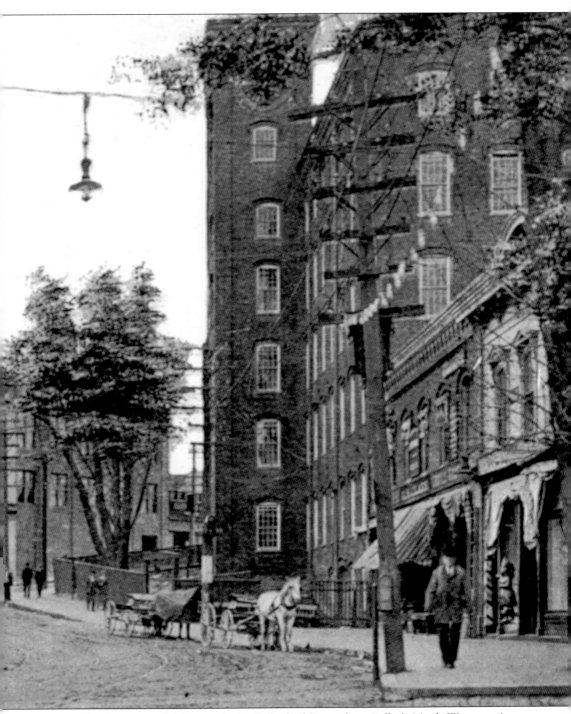

are gone. At the center of this scene is the Fuller building, where Fuller's Men's Wear continues to serve Amesbury to this day. In 1929, the front section of the No. 8 Mill bordering Main Street and including the town clock tower was removed, and a one-story store block was built in its place. The clock was moved to a shorter tower, which was lost with the rest of the building in the November 11, 1950 fire, and was never restored.

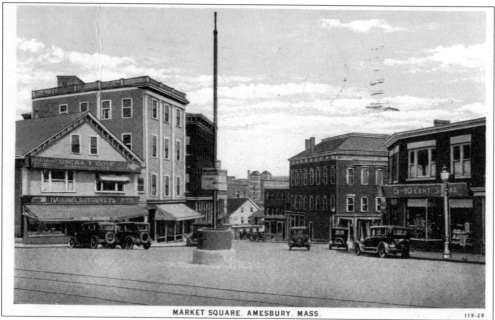

MARKET SQUARE, AMESBURY, MASS.

119-29

This view is looking down Elm Street with Water Street to the right. Oscar T. Gove Hardware and Paint and the National Butchers Company can be clearly seen at the left where the Provident Institute for Savings has now expanded its offices. The F.W. Woolworth five-and-dime store, the lamppost, and street signs in the middle of the rotary still exist as in this photograph.

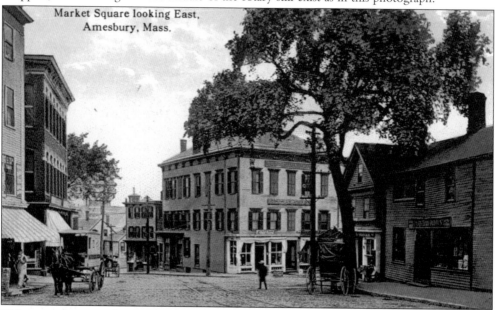

Market Square looking East, Amesbury, Mass.

This scene shows Market Square Plaza, looking down Elm Street. The building at the center of the photograph still exists, as does the brick building second from the left. Most likely, the carriages shown were manufactured and purchased in Amesbury. Visible are the tracks of the horse-drawn trolley that provided transportation between Amesbury and Newburyport. The town of Amesbury is currently restoring the area by adding period lighting, brick sidewalks, and literally dozens of shade trees.

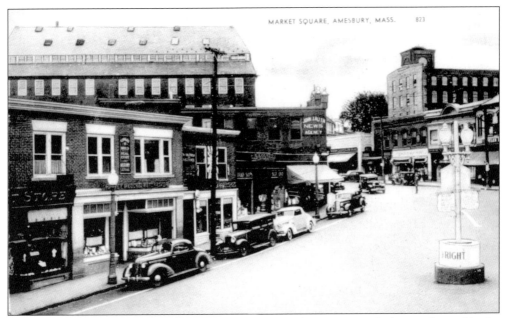

In 1870, an estimated 600 animals a day were watered at the water trough that was located in the center of Market Square by young boys who collected $5 or $10 to see to the watering needs of "parked" horses. In 1958, the water trough was rebuilt into the traffic island (seen at the right) that still exists today with the original direction signs affixed.

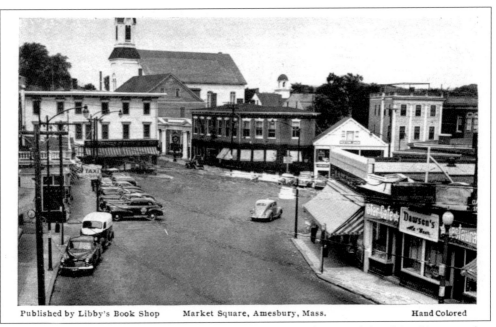

Published by Libby's Book Shop Market Square, Amesbury, Mass. Hand Colored

Market Square still has the quaint small-town appearance that is exhibited in this scene, but extensive renovating projects in Amesbury have enhanced the area with brick walkways, overhead shade trees, building murals, and a more "pedestrian friendly" traffic flow. The town motto is "You'd like Amesbury Too"—visit the town and find out why.

117

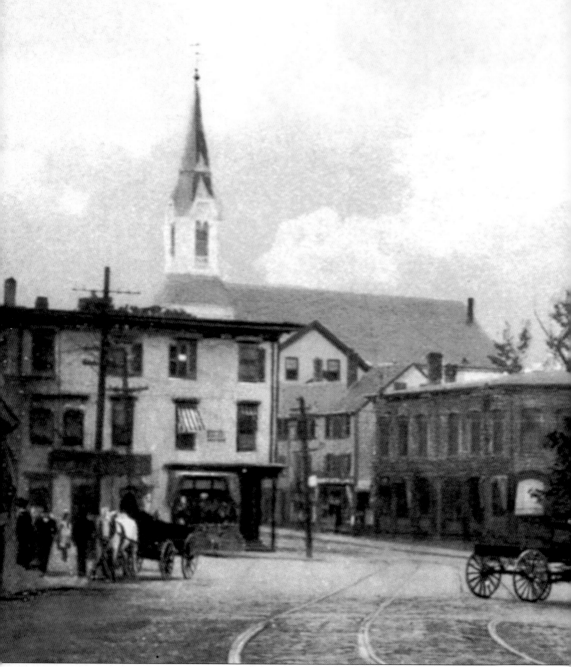

This view of Market Square shows the electric trolley tracks that ran between Amesbury and Newburyport or Amesbury, Merrimac, and Haverhill for 5¢. The square is watched over by the steeple of the Market Street Baptist Church. The Fred W. Peabody store at the right was a piano and organ store, and the Clark Drugstore was at the left. The brick building behind the center

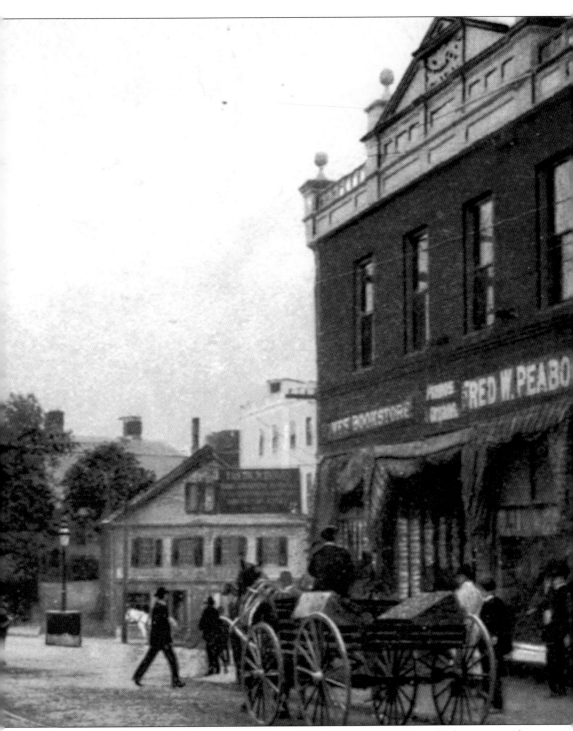

horse and buggy is the still in business as the Provident Institute for Savings. The lamppost with street signs in the center of the square has been renovated many times but still stands as a reminder of the past. The trolley to Salisbury Beach started here and wound through Elm Street past the Rocky Hill Meetinghouse.

This is a wide-body 1915 Chevrolet Amesbury Special. Although the term "runabout" fits the class of car, the Amesbury Special was much more so than a "roadster." It is possible that these runabouts were early Model H-3s—the fancy Amesbury Specials that were built in the New York City plant at the tail end of the 1914 model year. It is believed that these were called Amesbury Specials due to their origins of the bodies, which were made of wood.

The S. R. Bailey Carriage Factory, Amesbury, Mass.

The S.R. Bailey Company has a long record of achievement and has played an important role in Amesbury's progress, beginning with carriages and sleighs and pioneering an electric car in the early 1900s. A Bailey electric car once completed a 1,000-mile journey, culminating with an ascent to the summit of New Hampshire's Mount Washington. Bailey ceased production of the electric car in 1916 due to low sales and a relatively high price of about $2,400.

120

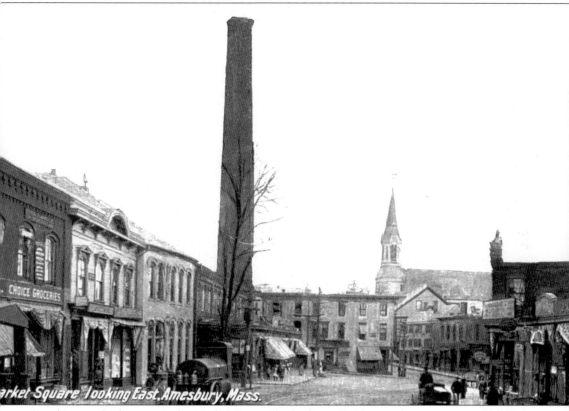

Reaching to the heavens is the Market Street "boiler house" chimney that was erected in 1871 by the Salisbury Mills Company and was a landmark of the town for decades. It stood unused for years and was removed in 1944.

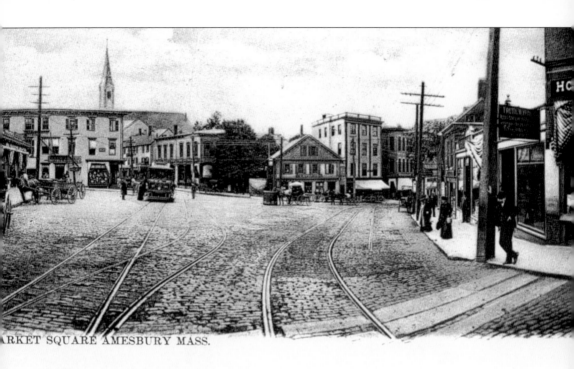

RKET SQUARE AMESBURY MASS.

Market Square bustled with trolley activity—both horse drawn and later electrically powered. Here, trolley No. 63, bound for Haverhill, and No. 73, destined for the Chain Bridge, cross on the double track in front of Merchant's Row on the right. In the foreground, note the wooden planks protecting pedestrians from muck, dust, and "road apples."

Nine

THE FLOOD OF 1936

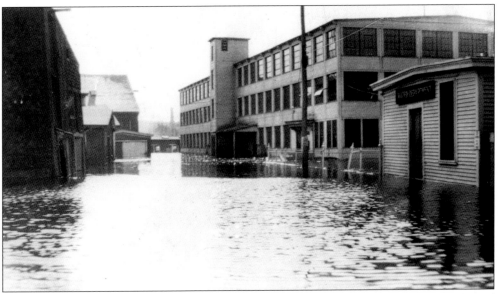

In early March 1936, the Commonwealth of Massachusetts Department of Public Works warned that "the climactic phenomena which developed in New England during March of 1936 indicated the probability of disastrous floods. Deep snows, thick ice coverage on all waters, coupled with long continuing heavy rains, accompanied by temperatures not only above normal, but abnormally high" would cause one of the worst floods the region has ever known.

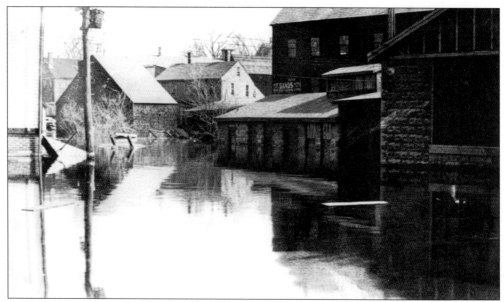

Factories of downtown Amesbury were submerged when the vast power of the Powow River, compounded with the added force of the rains and melting snows, ran over the banks with lightning speed. Warnings coming from many scientific predictions went unheeded, and merchants, owners, and residents were caught unaware to the immediate magnitude of the flood.

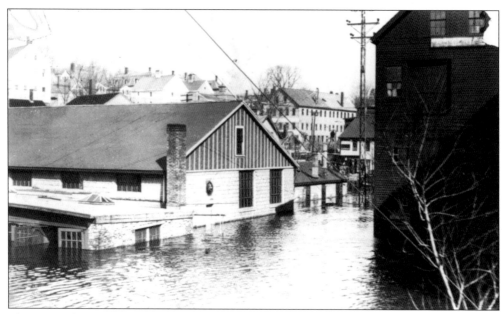

This view of Water Street in downtown Amesbury made its name especially prophetic.

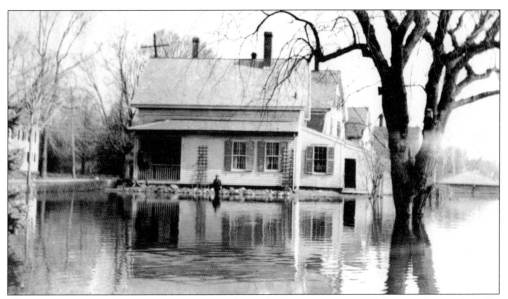

Every house along the Merrimac River—from the Powow River Bridge to Gunner's Point (Hawkeswood) at Salisbury Point (the location where the Essex-Merrimac Bridge meets Amesbury)—had a full cellar and water on the first floor. All of these houses were vacated except for the home of John and Anne Hession (shown here), which was the house nearest the Powow River Bridge. John Hession was quoted as saying, "We still have a few more inches."

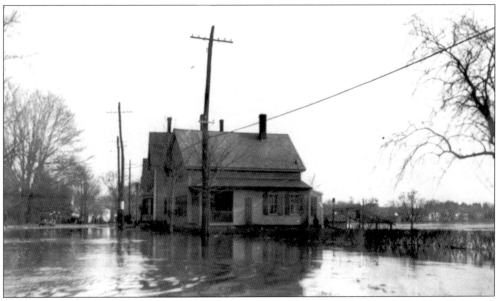

This view of 355 Main Street shows the level of the Merrimac River in the background at its widest point. It is very hard to fathom how this much water could be created in such a short time.

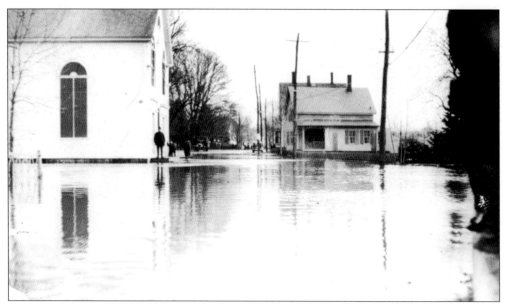

In the spring of 1936, 28 thunderstorms were recorded. Two hundred Works Progress Administration (WPA) workers quickly made much progress in clearing debris and disinfecting the cellars of private homes with chlorinated lime to prevent any possible disease. The WPA was a work relief program that was instrumental in providing jobs for many people who were unemployed during the Great Depression.

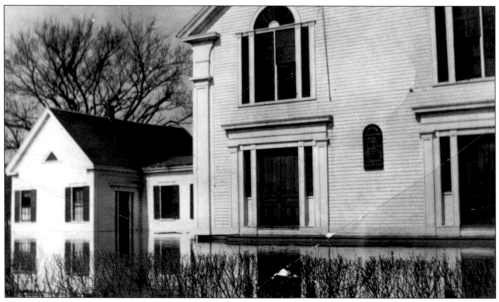

The Union Congregational Church suffered extensive damage beyond repair to its organ, and a Hammond organ has been in use since 1955. Services were suspended until the cleanup could be completed.

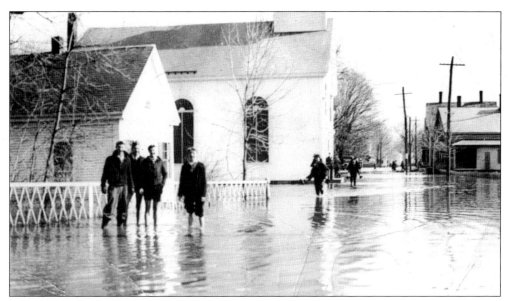

By the looks on these residents' faces, you would think that they were enjoying the flood, but the cleanup was yet to begin. Rivers during floods move a tremendous amount of rock and earth, which is pulverized and carried until the flow becomes less rapid and it is deposited like a fall of snow. This slimy silt was deposited with the consistency of molasses, which the highway departments vainly attempted to scrape off. It was found that the only effective way to clear the streets was with the force of a fire hose. In some places, the silt was as much as two and three feet deep.

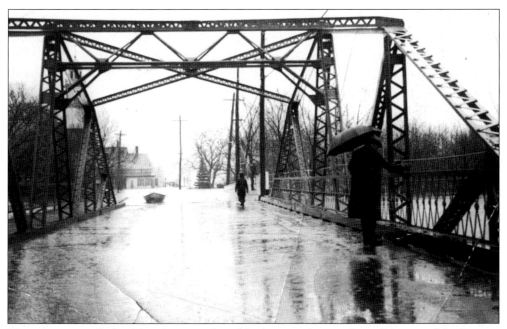

The rains were still thrashing the area when this photograph was taken of the top of the Powow River Bridge, facing toward Point Shore. To the right, just after the bridge, is Alliance Park completely submerged.

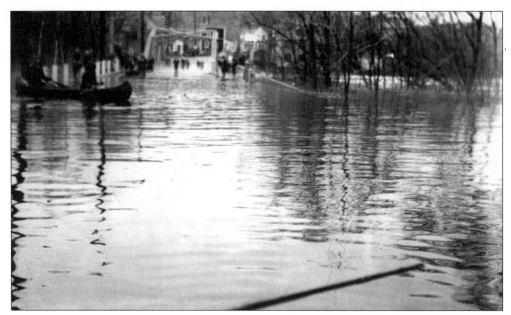

The average rainfall that March was 9.07 inches. At the Powow River Bridge, the high water mark was 16.3 feet above mean sea level. Where the Powow River bends behind the Union Congregational Church, the Powow and Merrimac Rivers became one. The banks extended some 500 yards toward each other. At the Union Congregational Church, the high water was recorded to be 3.8 feet above the center of the street.

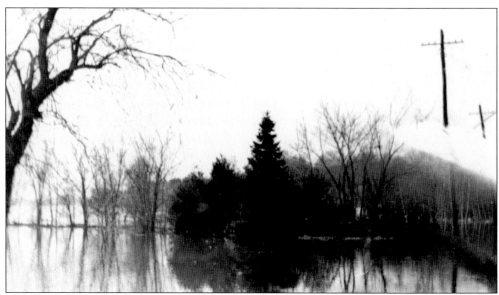

This is a view of Alliance Park from Main Street just beyond the Union Congregational Church. To the left, one can see how far the trees of the park are submerged. The white posts to the right are the entrance to the Powow River Bridge.